LANDSCAPES IN
bloom

10 FLOWER-FILLED SCENES
YOU CAN PAINT IN ACRYLICS

Jane Maday

NORTH LIGHT BOOKS
CINCINNATI, OHIO
www.artistsnetwork.com

ABOUT THE AUTHOR

Born in England and raised in the United States, Jane Maday has been a professional artist since she was fourteen years old. At sixteen, she was hired as a scientific illustrator at the University of Florida. After graduating from the Ringling School of Art and Design, she was recruited by Hallmark Cards, Inc., as a greeting card illustrator. She left the corporate world after her children were born; she now licenses her work onto numerous products such as cards, puzzles, needlework kits, T-shirts, etc., and she writes art instruction books and articles. She is the author of *Adorable Animals You Can Paint* and *Cute Country Animals You Can Paint* (North Light Books). Jane now lives in scenic Colorado with her husband and two children and a menagerie of animals. You can see more of her work or contact her through her Web site, www.janemaday.com.

Other fine North Light Books are available from your local bookstore, art supply store, online supplier or visit our website at www.fwmedia.com.

13 12 11 10 09 5 4 3 2 1

Distributed in Canada by Fraser Direct
100 Armstrong Avenue
Georgetown, ON, Canada L7G 5S4
Tel: (905) 877-4411

Distributed in the U.K. and Europe by David & Charles
Brunel House, Newton Abbot, Devon, TQ12 4PU, England
Tel: (+44) 1626 323200, Fax: (+44) 1626 323319
E-mail: postmaster@davidandcharles.co.uk

Distributed in Australia by Capricorn Link
P.O. Box 704, S. Windsor NSW, 2756 Australia
Tel: (02) 4577-3555

Library of Congress Cataloging in Publication Data
Maday, Jane.
 Landscapes in bloom : 10 flower-filled scenes you can paint in acrylics / Jane Maday.
 p. cm.
 Includes index.
 ISBN 978-1-60061-101-8 (pbk. : alk. paper)
 1. Landscape painting--Technique. 2. Acrylic painting--Technique. I. Title.
ND1342.M34 2008
751.4'26--dc22
 2008024660

Acknowledgments

This book wouldn't exist without the help of some wonderful people. Thanks go to Jackie Musser, my editor for her guidance, and to all the staff at F+W Media, for giving me these great opportunities. I'm very grateful! Special thanks go to Christine Polomsky for advising me on the photography and not losing patience with my endless questions! And thanks always go to my dear husband, John, just for being himself.

EDITED BY JACQUELINE MUSSER
DESIGNED BY JENNIFER HOFFMAN
PAGE LAYOUT BY DOUG MAYFIELD
PRODUCTION COORDINATED BY MATT WAGNER

ART ON COVER:
GAZEBO GARDEN

METRIC CONVERSION CHART

TO CONVERT	TO	MULTIPLY BY
Inches	Centimeters	2.54
Centimeters	Inches	0.4
Feet	Centimeters	30.5
Centimeters	Feet	0.03
Yards	Meters	0.9
Meters	Yards	1.1

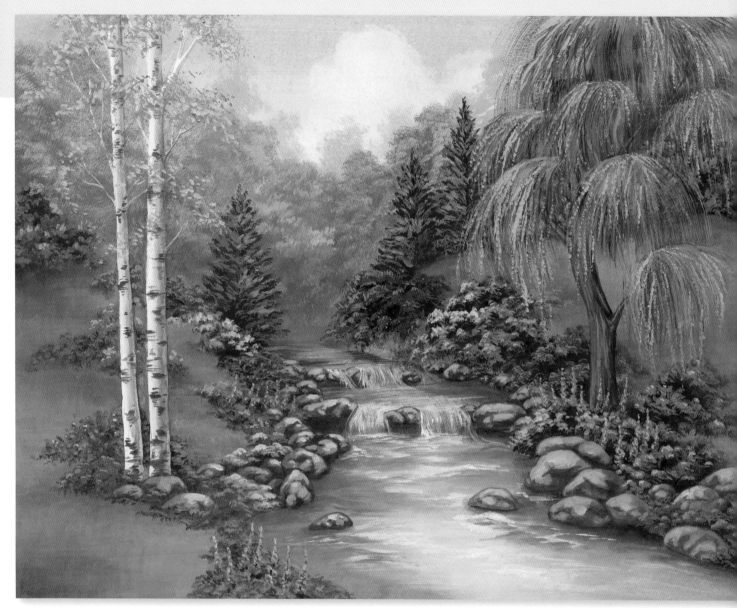

Dedication

To my mother, Jean McCoy, with all my
love, and thanks for always encouraging
me to find my way.

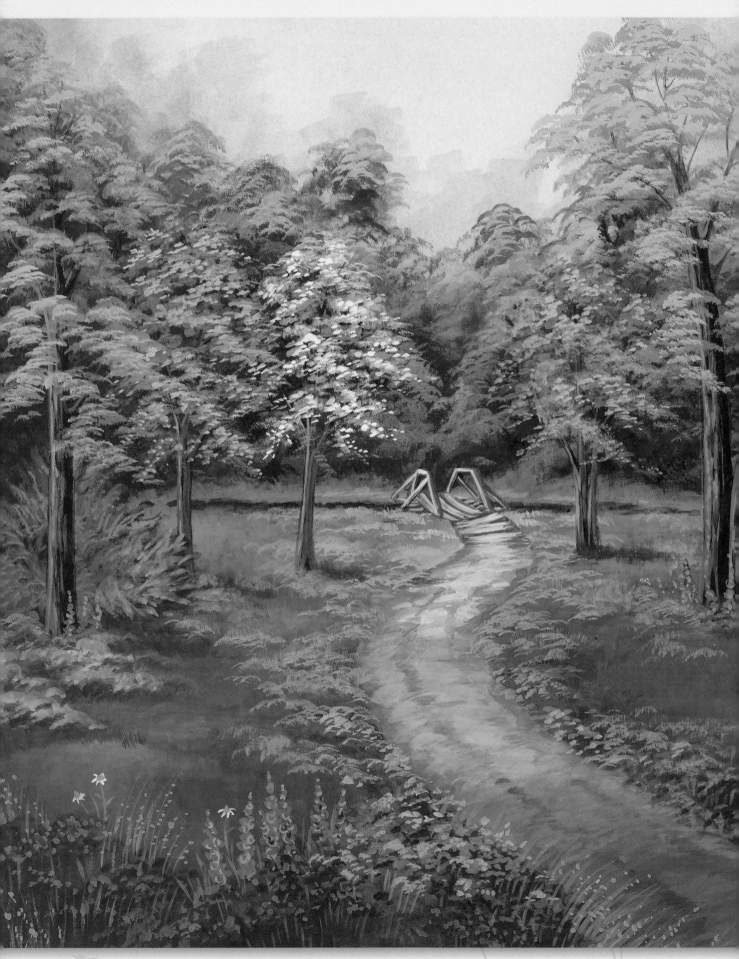

WOODLAND WAY

Table of Contents

maday

INTRODUCTION

This book is all about painting pretty landscapes. The paintings inside have been romanticized and represent a world of imagination based on the wonderful world we inhabit. I hope you take the tricks and techniques you'll learn when painting these projects and apply them to your own creations. Each painting in this book comes from years of experience as an artist and illustrator. I hope to share that experience with you and help you create your own. At the beginning of the book, you'll find a few mini demonstrations to help you with the techniques in the main projects. I have also included patterns for each project, but feel free to add or subtract from these as you wish. Remember, the painting you are making is your own, and you don't need to copy mine exactly. However, what you feel when painting is as important as the technical expertise, so the best advice I can give you is to relax and have fun!

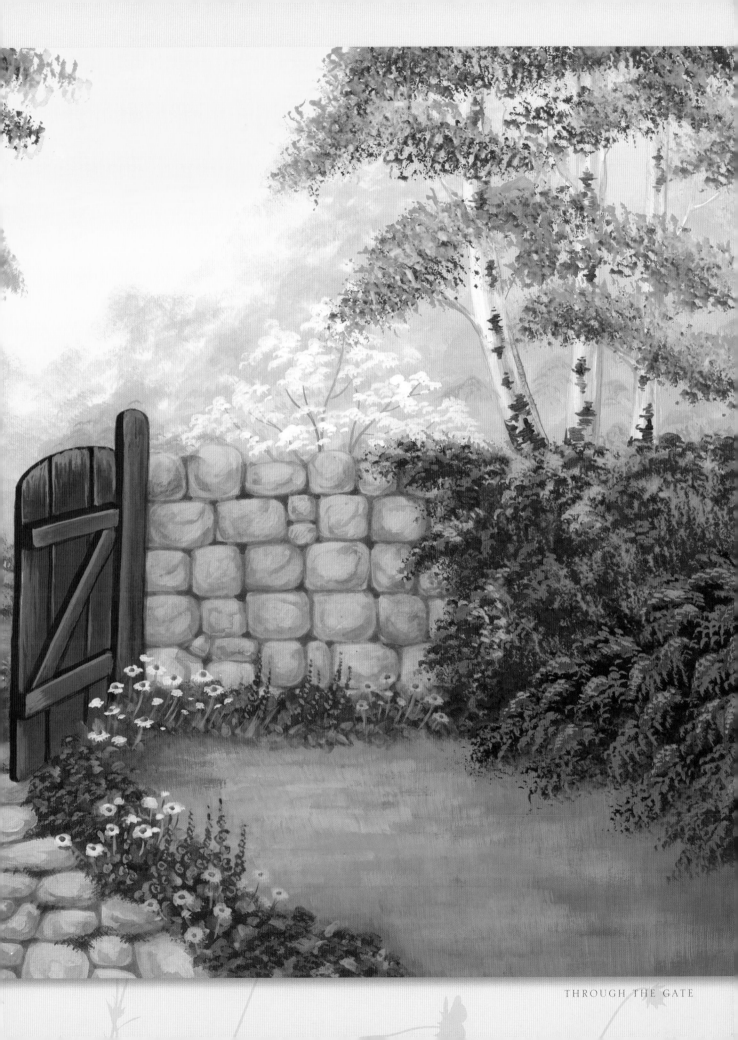

Materials

For each project, I have listed my favorite materials. You may substitute your favorite brands, of course, although some of the color names will differ between brands of paint. Color comparison charts are available on the Internet, if necessary.

PAPER

For this book, I have used Canson Montval cold press watercolor paper. Watercolor paper comes in hot-pressed, cold-pressed, and rough varieties. Hot-pressed is very smooth, and too slick for me. Cold-press has just the right amount of texture for my favorite techniques. I find that the texture of the rough surface paper makes it difficult to get smooth washes and fine details. I prefer paper that comes in a block, which is a pad of paper gummed on all four sides. When the painting is finished, you slide a knife between the sheets to release the top sheet. Using a block means you can skip taping the paper down on all sides to prevent buckling.

BRUSHES

For this book, I have used brushes from Royal & Langnickel. They are easily available in craft shops and online. Certain techniques, such as stippling, can be hard on your brushes, so I recommend having both old and new brushes. Keep the new brushes for techniques where you need the chisel edge to be sharp, and use the old ones for techniques where it doesn't matter.

PALETTE

Acrylic paints dry quickly, so I recommend using a wet palette, such as the Masterson Sta-Wet palettes. The damp sponge under the paper palette keeps the paints moist for a week. Remember to spritz the paints with water when you are finished with a painting session, and close the lid tightly.

SEA SPONGES

Several of the projects in the book use textures created by stamping paint with a sea sponge. It's a good idea to have several, with different sizes and shapes. Sea sponges are readily available in craft shops.

MASKING FLUID

Masking fluid comes in clear or tinted versions. I like the tinted, as it is easier to see. Sometimes masking fluid sits on the shelves in the shops for a long time before being purchased, and when you buy it, it has already started to thicken and harden. Always check the bottle before purchasing. Usually, giving the bottle a good shake to see how liquid the contents are is enough. See the section "Using Masking Fluid" (page 11) for tips on protecting your brushes.

PAINTS

For this book, I have used Plaid FolkArt acrylic paints and artists pigments. Artists pigments are the colors that are traditional in all brands of paint, such as Raw Umber or Yellow Ochre. The other acrylic paints are Plaid's own blends of colors. I use paint quite thin most of the time and prefer to dilute it with water rather than mediums. Plaid paints are nontoxic, but it is still a good idea to practice good habits and wash your hands frequently when painting and never eat or drink during a painting session.

OTHER SUPPLIES

At the beginning of each project, I have listed the supplies you will need. A few indispensable products are graphite and white transfer paper, drafting tape (not masking tape, as it is too sticky), tracing paper, and a sharp pencil with a hard lead, such as 4H (for transferring the pattern. You could also use a stylus for this). You'll also need a water container and some thick paper towels for blotting. In a few of the projects, I have suggested the use of a sharp colored pencil to help create straight lines.

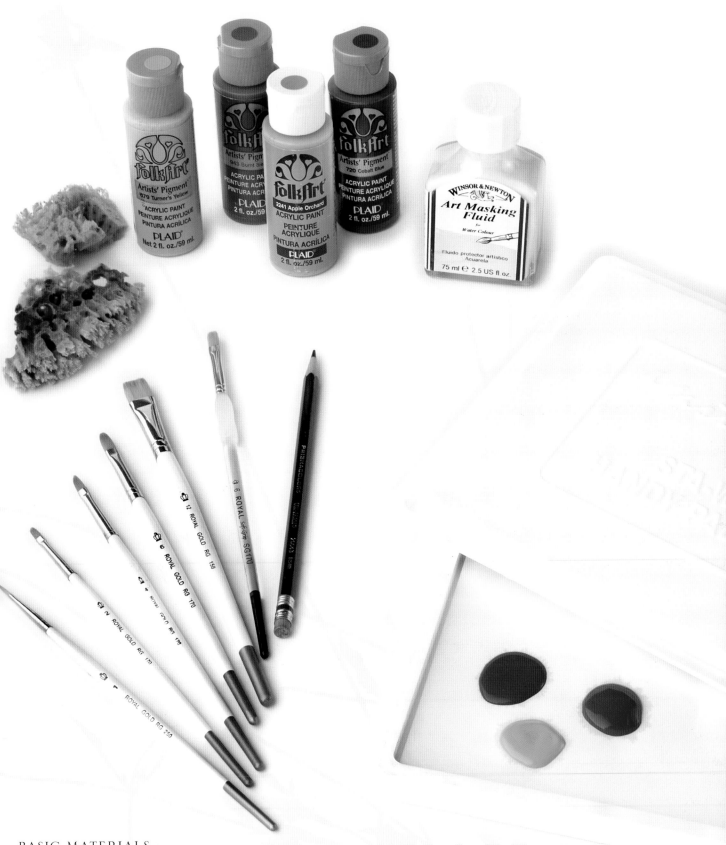

BASIC MATERIALS

Clockwise from top left, sea sponges, Plaid FolkArt acrylics paints, masking fluid, Masterson Sta-Wet pallette, Prismacolor Col-Erase pencil, Royal & Langnickel brushes: from right to left, soft grip no. 6 filber, no. 12 flat, no. 6 filbert, no. 4 filbert, no. 2 filbert, no. 1 round.

Before You Paint

USING A WET PALETTE

If you are unfamiliar with acrylics, you may be frustrated by how quickly they dry on a palette. This problem can be solved by using a wet palette, which you can purchase at craft and art supply stores.

A wet palette keeps your acrylics from drying as you work. The palette has a sponge that you soak before placing it on the palette. Do not wring out the sponge after wetting it.

Next, run or soak the disposable palette paper that comes with it under hot water until it's translucent. Place the wet paper on top of the sponge to use as your palette surface. These palettes also come with an airtight lid that will keep your paints moist for several days.

MOUNTING THE PAPER TO PREVENT BUCKLING

I prefer to paint on cold-pressed watercolor paper or Strathmore 500 series bristol board. This method of mounting works for both types of paper. (The 500 series accepts paint better than other Strathmore bristol board series and is the only type I would recommend.)

I prefer using watercolor paper in a block (a pad that is gummed on all four sides.) If you use single sheets of paper, you should mount them to a board to prevent buckling when the paper gets wet. Use drafting tape, rather than masking tape, because it can be removed without damaging the paper. Choose a backing board that is slightly larger than your paper.

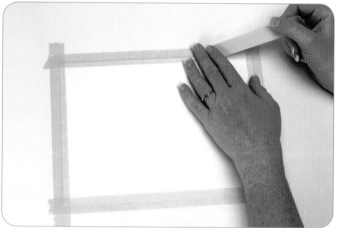

Tape the paper securely on all four sides, so all the edges are covered. If the paper does buckle, wait until the project is completely dry, then remove the paper from the backing board. Flip the paper over and tape it to the backing board again with the image side facing down. Lightly mist the paper with water from a spray bottle. As the paper dries, it should dry flat. Your project should always be completely dry before you remove it from the backing board.

TRANSFERRING A PATTERN

All the paintings in this book come with patterns you can trace and transfer onto your paper. I usually use graphite transfer paper, but occasionally I'll use white if I'm transferring details onto an already painted area.

Use drafting tape (not masking tape, which is too sticky) to tape the tracing paper and drawing to the paper. Use a mechanical pencil with a very hard, sharp lead (or a stylus) to transfer the pattern by

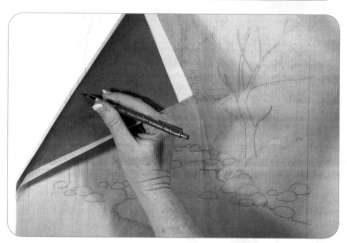

drawing over the lines. Check to make sure the transfer paper is graphite side down before you begin, or you'll end up transferring onto the back of the tracing paper!

Techniques

USING MASKING FLUID

Masking fluid helps protect areas of the paper that you want to remain white.

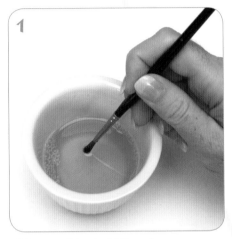

Step 1: Protect Brush

Masking fluid can ruin a brush if you're not careful. One way to preserve your brush is to dip it into a solution of equal parts water and dishwashing liquid. Tap off the excess on the side of the bowl, but do not rinse out the brush.

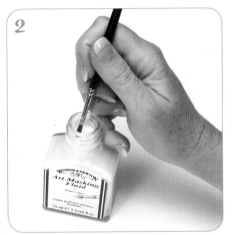

Step 2: Dip Brush in Fluid

Dip the brush into the bottle of masking fluid. Don't allow the masking fluid to go all the way up to the ferrule of the brush, where it could harden and ruin the shape of your brush. if you will be using the masking fluid for an extended period of time, pour a little out into a separate container so you can replace the lid on the bottle and keep it from drying.

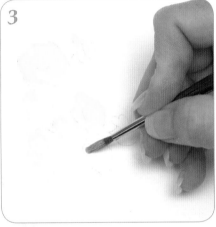

Step 3: Brush on Mask

Brush the masking fluid onto the area you need to mask. Let it dry completely.

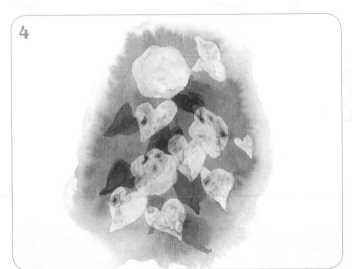

Step 4: Paint Uncovered Areas

Paint your background wash right over the mask.

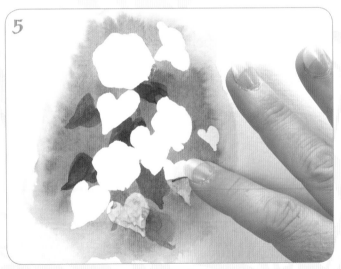

Step 5: Remove Masking Fluid

When the paint is dry, remove the mask by rubbing it lightly with a clean finger or a rubber cement pickup.

LOADING THE BRUSH

"Loading the brush" refers to filling your brush with paint.

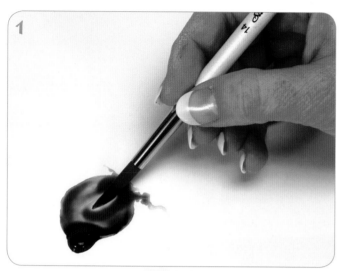

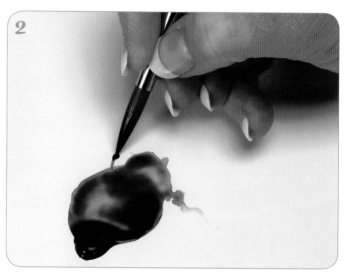

Step 1: *Create Puddle*

Place a small amount of paint onto the palette. Wet your brush in clean water. When you pull your brush out of the water, gently run the brush tip across a paper towel so it's not dripping wet. Use the brush at the edge of the paint dollop to create a small puddle.

Step 2: *Twirl Brush to Create Point*

Twirl the brush through the paint puddle to create at the end of the brush a fine point that will be retained. Before painting, run the brush tip lightly across a paper towel to remove any excess paint.

BRUSH MIXING ON A PALETTE

Step 1: *Create Puddle*

Start by pulling out a puddle of the first color with clean water on your brush.

Step 2: *Pick Up Second Color*

Rinse the brush and dip the tip into the second color.

Step 3: *Combine Colors*

Carry the second color and mix it into the puddle of the first color with circular motions of the brush.

Painting a Wash

A "wash" of paint means covering an area with a thin, watery layer of paint. I prefer to use water rather than mediums when painting with acrylics.

Wet the paper with clean water on a brush. Load your brush with the desired paint color and blot the excess on a paper towel. For a vignette background, do not start painting at the edge of the paper. Start painting just inside the wet area so the paint will bleed softly out to the edges. For a flat background, start at the edge and gradually work your way down the page, stroking back and forth with the brush.

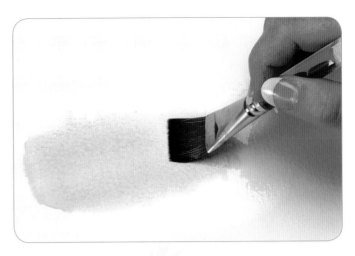

Glazing

"Glazing" refers to painting a thin transparent layer of color on top of a color that is already dry. Make sure the first layer is completely dry, or any subsequent layers will lift the paint underneath. Glazing can add depth to your colors that is hard to achieve otherwise. When glazing, thin the paint with water until it is very transparent. Lightly paint over the area where you want a tint of color (do not scrub with the brush). Soften the edges of the glazing with clean water if necessary. The first photograph shows the image before glazing. The second photograph is after glazing. Notice how the second picture has a glowing warmth that the first one lacks.

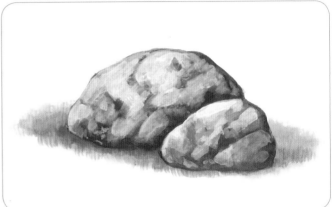

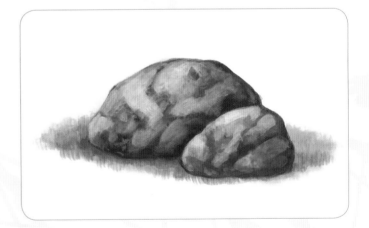

Stippling

"Stippling" refers to painting with the brush held straight up and down and tapping the paint lightly onto the paper with a pouncing motion. Don't tap too hard, or you will get blobs of paint rather than little specks. The bristles of the brush should flare out. This technique can be kind of hard on your brushes, so I use older brushes when painting this way.

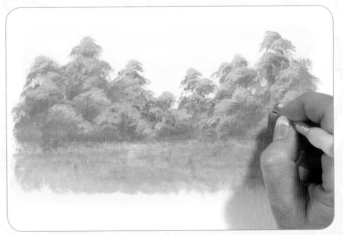

LIFTING OUT CLOUDS

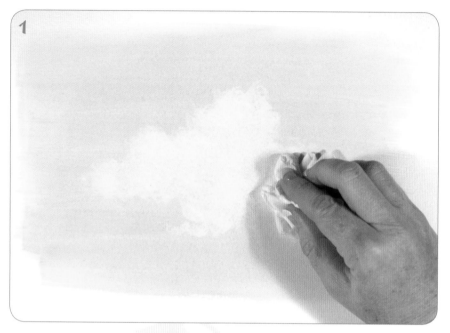

Step 1: Paint Wash, Lift Out Paint

Wet the paper with clean water. While the paper is wet, paint a wash of Coastal Blue. The paint should be diluted to a creamy consistency. Before the paint dries, lift out cloud shapes by patting the paint with a crumpled facial tissue.

Step 2: Add Color

To add a delicate blush of dawn color, dilute Baby Pink until very thin and transparent and paint a few washes, using circular motions of the no. 6 round brush. Touch up wherever necessary with Titanium White.

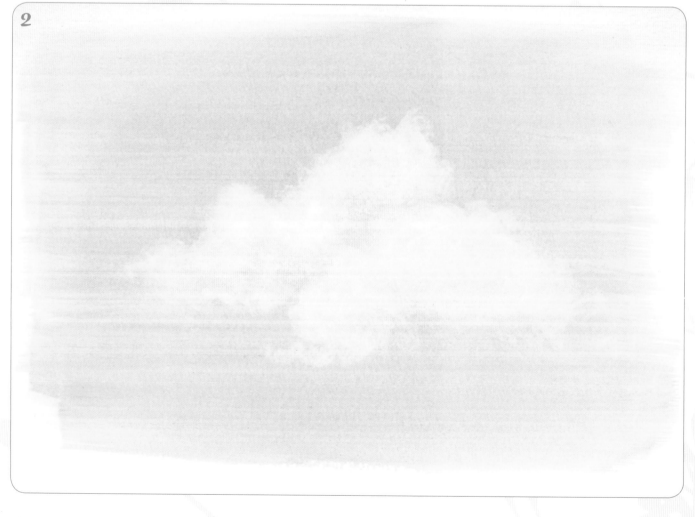

Painting With a Sponge

Using a sponge is a simple and effective way to add texture to a painting. I like to use them to paint foliage.

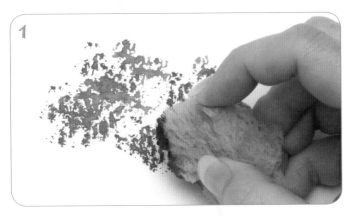

Step 1: Load Sponge and Stamp On Color

Brush mix Hooker's Green Permanent Hue + Brilliant Yellow Green (1:1) on your palette. Check a natural sea sponge first to see which side has the shape and texture most appropriate for the object you are painting, then slightly dampen the sponge and dip it into the paint puddle. Test first on a piece of scrap paper to make sure there is not too much paint on it. Stamp the first clusters of leaves.

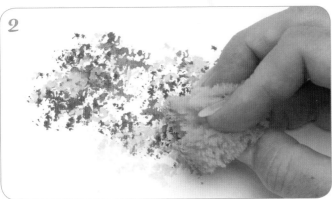

Step 2: Stamp On Highlight

Rinse out the sponge and squeeze out the excess water. Brush mix Titanium White into the green mixture from Step 1. Stamp less of this new mixture than the first, and don't stamp too much. Make sure plenty of background shows through to give the leaves an airy, open appearance.

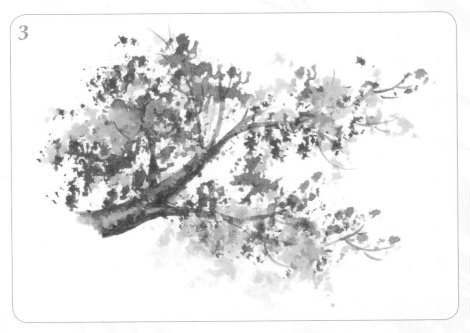

Step 3: Paint Branch

Basecoat the branch with Raw Umber on a round brush. Use a smaller brush for the thinnest twigs. Shade the branch with Raw Umber + Payne's Gray (1:1) and highlight it with Titanium White + a touch of Raw Umber. Use the brush and the lighter green mixture from Step 2 to paint a few leaves overlapping the branch.

Zinnias

In my area, zinnias bloom in late summer and early autumn. In this demo, I have tried to show some color variations of this variety. To prepare, I covered the flowers with masking fluid, let it dry, and did a loose wash of Sap Green with a ¾-inch (19mm) wash brush. Make loose, leafy shapes with more Sap Green while the first wash is still wet.

1
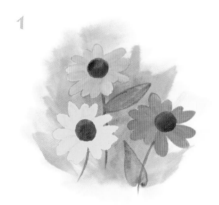

2
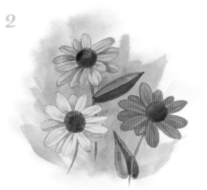

3
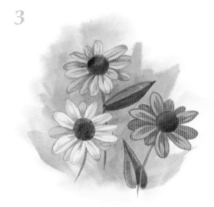

4
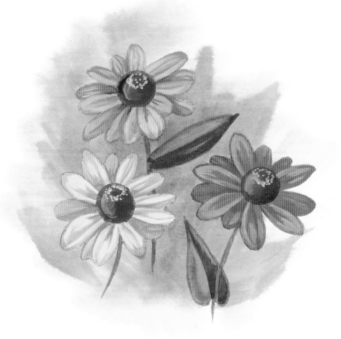

Step 1: Basecoat Flowers

With the no. 3 round, paint the yellow petals with Yellow Light + Tangerine (1:touch), the orange petals with Tangerine, and the red petals with Red Light + Tangerine (1:1). The flower centers are Raw Umber. The leaves and stems are Sap Green + Apple Orchard (1:1). All the paint should be diluted to a milky consistency.

Step 2: Shade

Dilute Sap Green to an inky consistency and shade one side of each leaf. Then add a little more shading to the edge of the other side of the leaf. Shade the yellow petals with Yellow Ochre. Add slightly darker touches with Raw Sienna. Shade the orange petals with Red Light + Light Red Oxide + Sunflower (2:1:1). Shade the red petals with Light Red Oxide.

Step 3: Highlight Petals

With the no. 3 round, highlight the yellow petals with Titanium White + Yellow Light (2:1). Do not highlight every petal; some are underneath the others. Highlight the orange flower petals with Titanium White + Tangerine + Yellow Light (2:1:1). Highlight the red petals with Titanium White + Yellow Light + Red Light (2:1:1).

Step 4: Highlight Leaves

Highlight the leaves with Apple Orchard + Titanium White (1:1), and the flower centers with Raw Umber + Sunflower (2:1). Glaze thin Yellow Light over the highlights. This helps reduce any chalky appearance caused by the Titanium White. Finally, dot pollen onto the flower centers with Yellow Light + Tangerine (1:touch).

Wild Sunflowers

Wild sunflowers have smaller flowers than the cultivated variety, but their petals are just as bright and cheery. To prepare, I masked the flowers, then painted a wash of Sap Green behind them. When dry, add a few loose, leafy shapes with more Sap Green and the no. 6 round.

1

2

3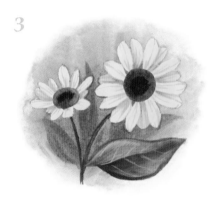

Step 1: Basecoat Flowers
Paint the leaves and stems with Hauser Green Dark, diluted to a milky consistency, using the no. 3 round. The flower centers are Burnt Umber, and the petals are Yellow Light + Titanium White (1:touch).

Step 2: Create Form With Highlight and Shading
Highlight the leaf with Soft Apple + Apple Orchard (1:1). When dry, glaze with diluted Sap Green. Shade the petals with diluted Yellow Ochre, using the no. 3 round. Stipple a dark center into the flower with the no. 4 filbert and Burnt Umber + Payne's Gray (1:1).

Step 3: Add Highlights and Details
Add highlights and details to the leaves with Apple Orchard + Titanium White (1:touch) and the no. 0 round. Detail the petals with Yellow Ochre + Burnt Umber (1:touch). Glaze a little Yellow Light across the leaf.

Step 4: Add More Highlights
With the no. 4 filbert, stipple texture into the flower centers with Burnt Umber + Titanium White (2:1) and Sunny Yellow + Yellow Ochre (1:1). Let the texture overlap the petals a little. Highlight the petals with Titanium White + Yellow Light (1:touch) and the no. 0 round. Do not highlight every single petal; some are underneath the others and are in shadow.

4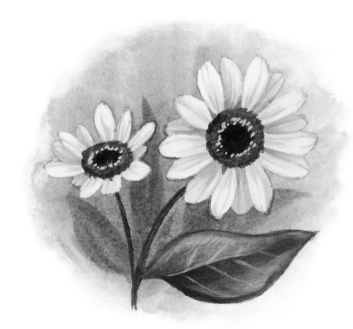

Hollyhocks

I love hollyhocks. I find them especially useful in a painting if you need a flower that is very tall and that will show over the tops of other, shorter flowers. To prepare for this demo, I masked out the flowers with masking fluid and painted a thin wash of Sap Green behind them.

1

2

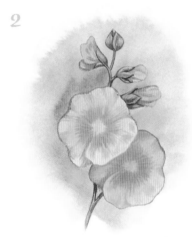

Step 1: Basecoat Flowers

With the no. 6 round, paint the flowers with Light Peony and the stems with Apple Orchard + Coastal Blue (1:1). The paint should be only slightly diluted to a creamy consistency. Glaze the overlapped flower with Light Peony + Red Light (1:touch).

Step 2: Add Shading

Using the no. 3 round, shade the flowers with Butler Magenta + Alizarin Crimson (1:1) thinned to a milky consistency. Shade the stems with Sap Green, diluted until it is inky.

3

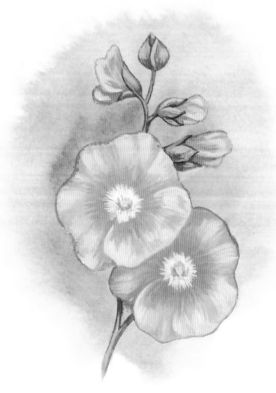

Step 3: Add Final Details and Highlights

With the no. 3 round, paint the flower centers with Titanium White. When dry, paint a little Sap Green + Titanium White (1:1) in the center and a dot of Sunny Yellow in the middle of that. Highlight the petals with Titanium White + Light Peony (1:1). Highlight the green stems and flower buds with Soft Apple.

Cats

In my days as a professional illustrator, a general rule of thumb was that if you want to add warmth and emotion to a painting, you should "put a cat in it." To that end, I have included this demonstration of kittens and cats that you can place in any of the projects in this book if you wish. Simply copy them at the size you need on a photocopier, then trace them into your pattern.

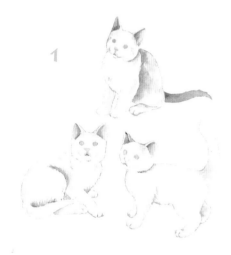

Step 1: Base Features, Shade

Dilute Raw Umber until it is very thin and transparent, and shade the cats with the no. 3 round. Paint their eyes with Forest Moss and the no. 0 round. Their noses and inside their ears are Baby Pink.

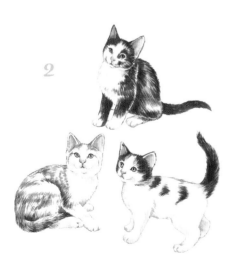

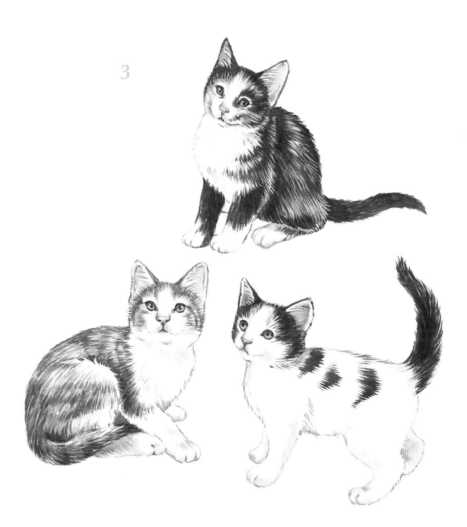

Step 2: Add Dark Details

Add the dark details with the no. 0 round and Payne's Gray + Raw Umber (1:1). Dilute the paint to a creamy consistency so it flows easily. The details of the mouth and nose are Raw Umber. When painting fur, your brushstrokes should go in the direction of fur growth so the strokes taper at the end of the fur.

Step 3: Paint Light-Colored Fur

Add the golden fur with diluted Raw Sienna + Raw Umber (1:1), and white fur with Titanium White. Don't forget to place Titanium White highlights in the eyes. If desired you can add very thin Raw Sienna touches to the eyes and noses as well.

Tree Bark

This demo shows the differences in painting aspen tree bark and other tree bark. One important difference is that the aspen bark is painted with horizontal strokes, while other bark needs vertical brush strokes. To prepare, I masked the tree trunks, then painted a wash of Coastal Blue behind them.

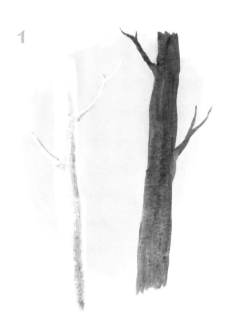

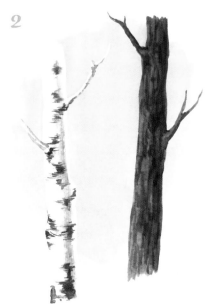

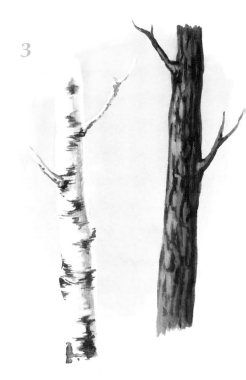

Step 1: Basecoat Trunks

Touch up the aspen with Titanium White if necessary. Leave as much plain white paper as possible. With the no. 6 round, shade the aspen trunk with Raw Umber diluted with water to an inky consistency. Leave a little white rim; don't shade all the way to the edge. This reflected light helps the tree look more round.

Paint the other trunk with Raw Umber + Titanium White (1:touch).

Step 2: Add Dark Details

With the no. 3 round, paint the darks on the aspen with horizontal strokes of Raw Umber + Payne's Gray (1:1).

Shade the other tree with the same mix, diluted to an inky consistency. When dry, use the paint a little thicker to paint details in the bark, still using the no. 3 round brush.

Step 3: Add Highlights

Glaze a little very thin Raw Sienna along the shaded area of the aspen. When dry, add a few Titanium White details with the no. 3 round.

Highlight the other trunk with Raw Umber + Raw Sienna + Titanium White (1:1). When dry, glaze a little Raw Umber over the shaded side.

Background Foliage

When painting distant trees, the colors you choose should be closer to the sky color than the colors you choose for the foreground. Objects that are far away also have less contrast between dark and light than those that are closer. For this demo, I painted the sky with a wash of Coastal Blue and the grass with Sap Green, Apple Orchard + Soft Apple (1:1) and Yellow Ochre.

1

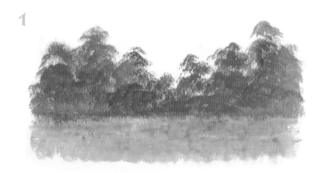

Step 1: Stipple Dark Foliage
With the no. 8 filbert brush, stipple background trees with Sap Green + Coastal Blue (1:generous touch). Mixing a touch of the sky color into the foliage color helps it recede to the background. Make sure the foliage is not too solid; glimpses of sky should show through.

2

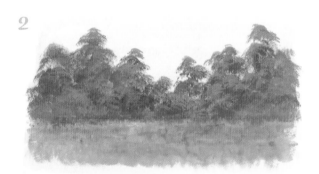

Step 2: Stipple Light Foliage
Stipple lighter foliage with Apple Orchard. Use the paint fairly dry, and tap the brush lightly on the page. Make sure plenty of the base color still shows through.

3

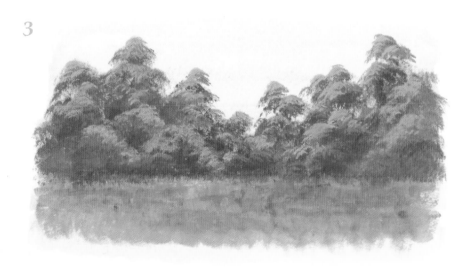

Step 3: Stipple Lightest Foliage
Add the lightest foliage with Soft Apple + Apple Orchard (1:touch), still stippling with the no. 8 filbert.

Rocks

Painting the texture of rocks is fun. You can vary the colors and make them more gray or brown, but the technique for achieving the texture is the same. To prepare, I masked out the rocks, then painted the grass with short vertical strokes of the no. 8 flat and Sap Green, Apple Orchard and Yellow Ochre.

1

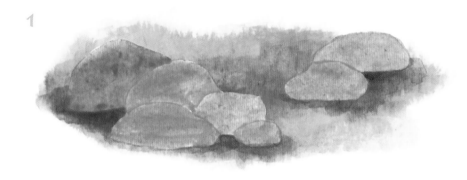

Step 1: Basecoat the Rocks

Paint the rocks with Raw Umber + Payne's Gray + Titanium White (1:touch:touch) and the no. 6 round. The paint should be diluted to a milky consistency. Paint each rock separately, rather than doing the whole clump as one mass. Glaze a little Payne's Gray beneath the rocks for shadows.

2

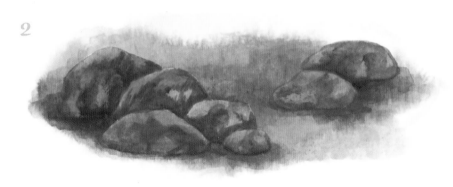

Step 2: Develop Texture

Using the paint fairly dry, develop the rocks with Payne's Gray and Raw Umber with the no. 6 round brush. You can roll and scuff the brush to add texture. Using the paint dry also allows some of the texture of the paper to show through.

3

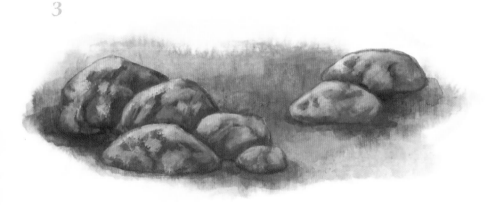

Step 3: Highlight and Glaze

With the no. 6 round, highlight the rocks with Titanium White + Raw Umber (1:touch), still using the paint quite dry. Make Raw Sienna very thin with water and glaze a little over the top of the rocks, especially on the shadow sides. If desired, you can also glaze a little Forest Moss in places for a slightly mossy appearance.

Rushing Water

A lot of beginners tend to paint water using too much blue. It's important to remember that water reflects the colors surrounding it. Seawater can sometimes look more blue than river water because it is reflecting mostly sky. If you are having trouble blending, try dusting the wet paint with light strokes of a soft, dry mop brush. To prepare for this demo, I painted the riverbanks with washes of Sap Green and Raw Umber and added rocks following the techniques from the rock mini demonstration.

Step 1: Paint Wash for Stream
Wet the paper where the water will go. Paint the water with a wash of Coastal Blue + Sap Green (1:1), using a no. 6 round. Working quickly, while the paint is still wet, paint horizontal strokes with Titanium White in the center of the water.

1

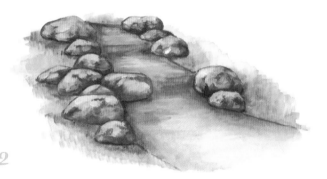

Step 2: Add Darks to Water
Mix Payne's Gray + Sap Green (2:1) and add darks to the water with the no. 6 round. Blend with clean water as you go. The water should be darker in the background. When dry, glaze a little Forest Moss along the edges, and add streaks of Coastal Blue + Sap Green (2:1).

2

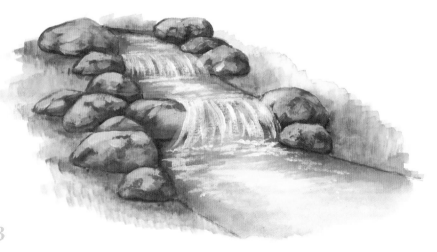

Step 3: Add Cascades
With the no. 8 flat, glaze a little more Titanium White in the center of the water with horizontal strokes. Holding the brush straight up and down, stipple a few ripples with Titanium White, using the paint quite thick. Paint curved strokes with Titanium White where the water cascades over the rocks. Blend a little of the Coastal Blue + Sap Green mixture into the center of the white water splashes, using the no. 6 round.

3

Path

A path can be a very useful device for leading the viewer's eye through a painting. Paths can be made of brick, stepping stones or exposed earth. To prepare this demo, I painted the grass with Sap Green, Apple Orchard and Yellow Ochre.

1

Step 1: Basecoat Path
Basecoat the path with a wash of Raw Umber diluted to an inky consistency.

2

Step 2: Paint Path
Using loose brushstrokes, paint the path with Sunflower + Raw Sienna (3:1), using the no. 6 round. The paint can be quite thick and opaque here. Shade the edges of the path with thin glazes of Raw Sienna.

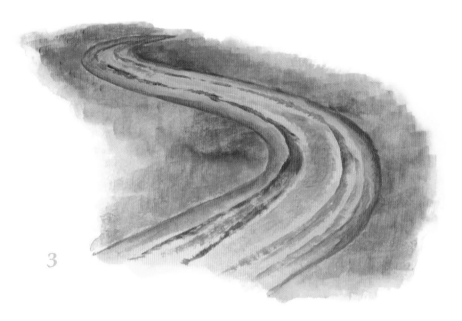

3

Step 3: Add Ridges

Paint the ridges on the path with Raw Umber + Raw Sienna (1:1), still using the no. 6 round. Blend the paint with clean water as you go. Your brushstrokes do not need to be completely blended; a little texture is fine.

Step 4: Add Highlights and Details

Brush mix a little Titanium White into the Sunflower + Raw Sienna mixture from Step 2 and highlight the ridges on the path with the no. 3 round. Add a few glazes of Raw Umber when dry. Add a little grass overlapping the edges of the path with Apple Orchard and the no. 4 filbert.

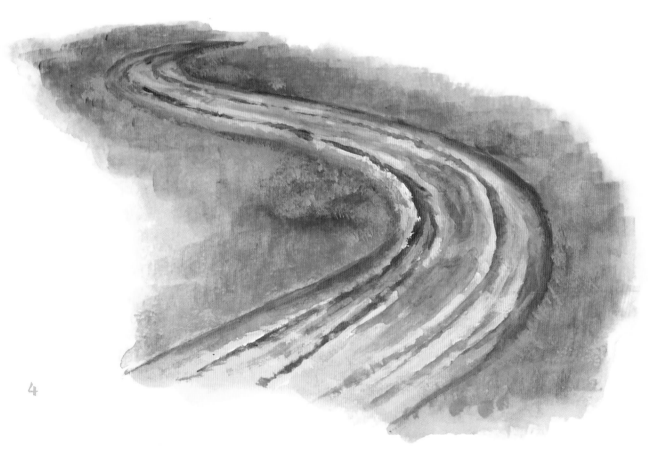

4

Gazebo

To prepare, cover the gazebo with masking fluid. Wet the paper with clean water, and paint a wash of Sap Green with the no. 10 round brush. Add shrubbery with more Sap Green and the no. 8 filbert. Highlight with Apple Orchard + Titanium White (1:1).

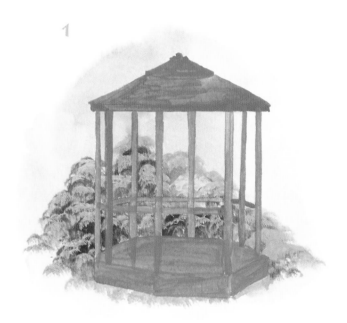

Step 1: Basecoat
After removing the masking fluid, retransfer the details if necessary. Basecoat the gazebo with Burnt Umber + Titanium White (1:1) and the no. 6 round (or a smaller brush if you prefer).

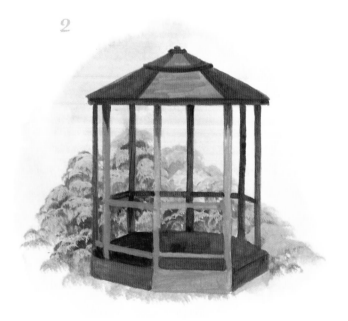

Step 2: Shade
Dilute Raw Umber to an inky consistency and shade with the no. 3 round.

3

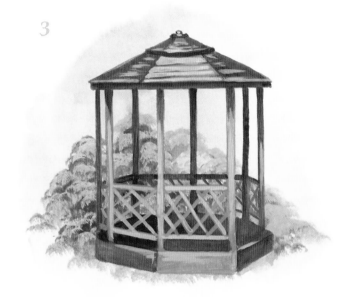

Step 3: Highlight

Highlight with Titanium White + Burnt Umber
(2:1) and the no. 3 round. Brush mix more
Burnt Umber into the mix to add a few details.

4

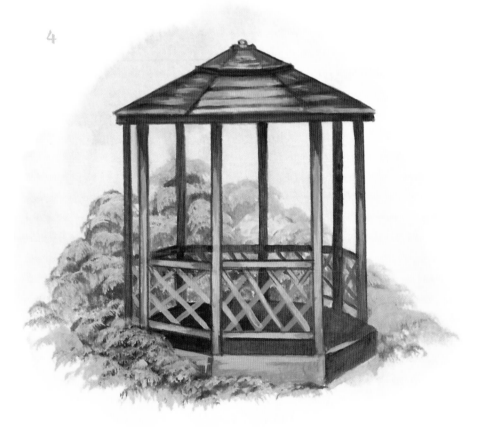

Step 4: Detail and Glaze

With a ruler and a brown colored pencil,
touch up the straight lines. Glaze very thin
Raw Sienna over portions of the gazebo to
add warmth. Add more foliage if desired.

Rose Arbor

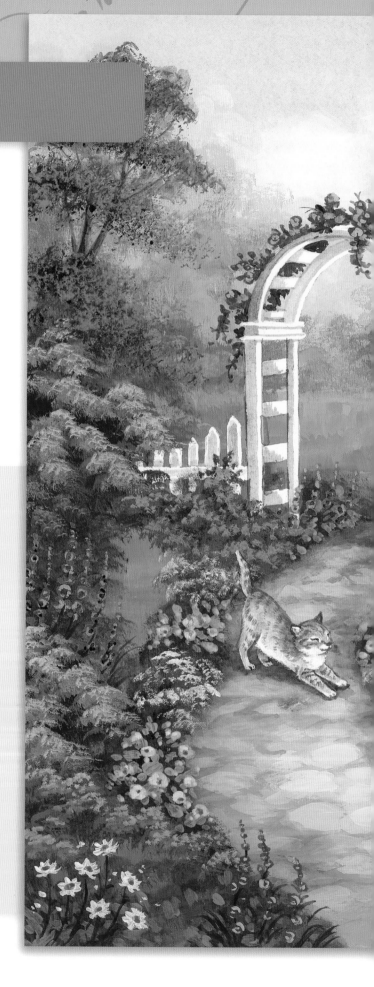

MY HUSBAND BUILT A ROSE ARBOR FOR ME IN THE GARDEN OF THE FIRST HOUSE WE OWNED AFTER WE GOT MARRIED. WE MOVED AWAY LONG AGO, BUT IN THIS PAINTING I IMAGINED WHAT IT MUST LOOK LIKE NOW. IF THE CAT AND BIRD IN THIS PAINTING ARE TOO DETAILED FOR YOU, YOU CAN LEAVE THEM OUT.

MATERIALS LIST

SURFACE
12" × 16" (30cm × 41cm) Canson Montval cold press watercolor paper

BRUSHES
1-inch (25mm) wash; nos. 0, 3 and 6 rounds; no. 8 filbert; no. 12 flat

PLAID FOLKART ACRYLIC PAINT
Apple Orchard, Coastal Blue, Forest Moss, Green Forest, Parisian Pink, Soft Apple, Sunny Yellow

PLAID FOLKART ARTIST'S PIGMENTS
Brilliant Ultramarine, Burnt Umber, Butler Magenta, Hauser Green Dark, Payne's Gray, Raw Sienna, Red Light, Sap Green, Titanium White

OTHER SUPPLIES
drafting tape (not masking tape), facial tissue, graphite transfer paper, masking fluid, sea sponge, sharp pencil or stylus, white transfer paper (optional)

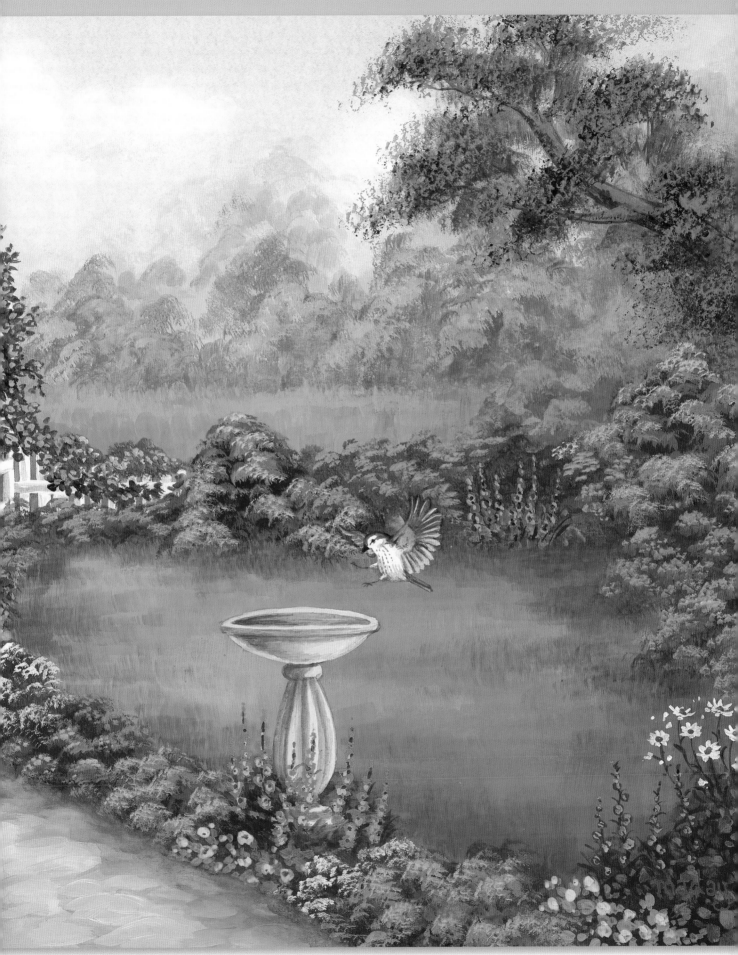

PATTERN

This pattern may be hand traced or photocopied for personal use only. Enlarge at 200% on a photocopier to bring it up to full size.

PREPARE FOR PAINTING

Tape off an 11" × 14" (28cm × 36cm) area on the paper with drafting tape. Transfer the pattern, except for the trees, with the graphite transfer paper and a sharp pencil or stylus (see page 10). With the masking fluid, protect the cat, birdbath, bird, arbor and fence (see page 11). If you feel unable to mask an item as small as the bird, skip that for now. When it is time to paint the bird, transfer it onto the painting with white transfer paper and basecoat it with Titanium White first.

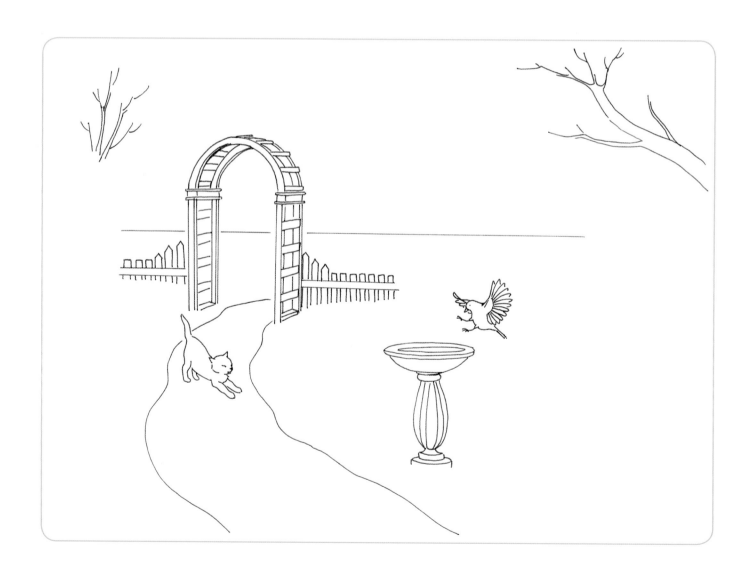

COLOR MIXES

Red Light + Sunny Yellow (1:1)

Parisian Pink + Red Light (1:1)

Butler Magenta + Titanium White + Coastal Blue
(2:1:touch)

Butler Magenta + Coastal Blue (2:1)

Titanium White + Forest Moss (2:1)

Sap Green + Apple Orchard (1:1)

Sap Green + Apple Orchard + Coastal Blue
(1:1:touch)

Green Forest + Titanium White (1:1)

Raw Sienna + Burnt Umber (1:1)

Titanium White + Raw Sienna + Payne's Gray
(2:1:touch)

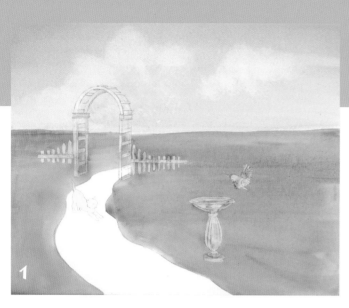
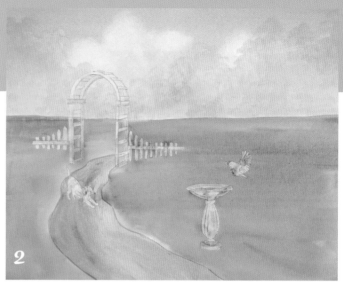
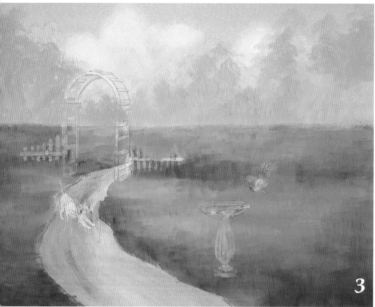
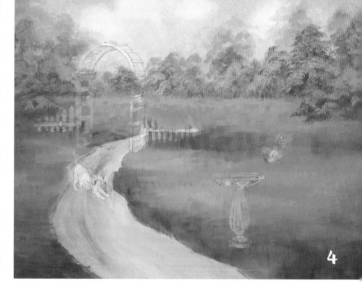

Step 1: Wash In Sky, Grass

Wet the sky with clean water and the 1-inch (25mm) wash brush. Dilute Coastal Blue to an inky consistency and paint the sky. Blot out clouds with a crumpled facial tissue while the paint is still wet (see page 14). When dry, paint the grass with a wash of Sap Green.

Step 2: Paint Clouds, Path, Distant Bushes

With the no. 6 round, touch up the clouds with Titanium White and paint a wash of Raw Sienna on the path (see page 13). Paint distant bushes with the no. 8 filbert and Butler Magenta + Titanium White + Coastal Blue (2:1:touch). Mix in a little more Titanium White for lighter areas along the edges.

Step 3: Paint Grass

Begin painting grass with Sap Green + Apple Orchard (1:1), Apple Orchard and Soft Apple using the 1-inch (25mm) wash brush and short vertical strokes. Mix Titanium White + Forest Moss (2:1) and add more background foliage with the no. 8 filbert.

Step 4: Add Background Foliage

Mix Sap Green + Apple Orchard + Coastal Blue (1:1:touch) and stipple more bushes with the no. 8 filbert. Add lighter foliage with the Titanium White + Forest Moss (2:1). Soften the grass line along the background trees with Apple Orchard + Titanium White (1:1). See page 21 for more instruction on painting background foliage.

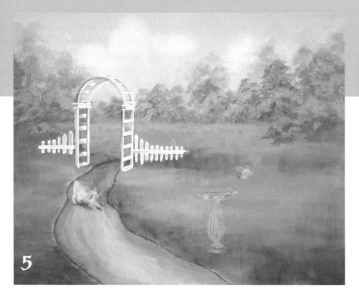

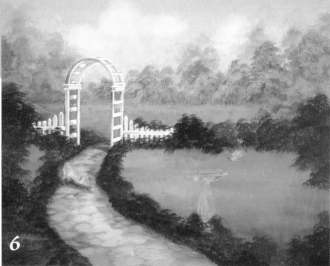

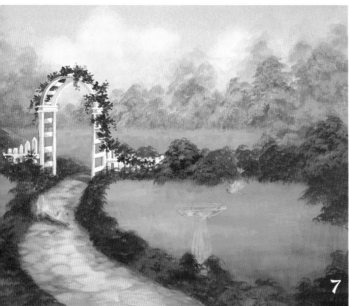

Step 5: Paint Arch, Fence

Shade the path with thin washes of Burnt Umber and the no. 6 round. Remove the masking fluid from the arch and fence. Retransfer lines as necessary and shade with very diluted Payne's Gray and the no. 3 round. Touch up edges with Titanium White.

Step 6: Detail Path

Brush mix several combinations of Raw Sienna + Titanium White and paint the path with curved horizontal strokes of the no. 6 round. Shade with glazes of Burnt Umber.

Paint more foliage with Hauser Green Dark and Sap Green + Apple Orchard (1:touch) and the no. 8 filbert.

Step 7: Highlight Foliage, Paint Rose Leaves

Mix Green Forest + Titanium White (1:1) and stipple lighter foliage on top of the Hauser Green Dark areas with the no. 8 filbert. Paint the leaves for the climbing rose with the no. 3 round and Sap Green.

Step 8: Detail Roses, Add Trees

Dot in lighter leaves with Apple Orchard + Titanium White (1:touch) and the no. 3 round. Add a few stems with Burnt Umber.

Lightly transfer the tree trunks. Paint them with Burnt Umber + Titanium White (1:touch). Stipple foliage with Sap Green and the no. 8 filbert.

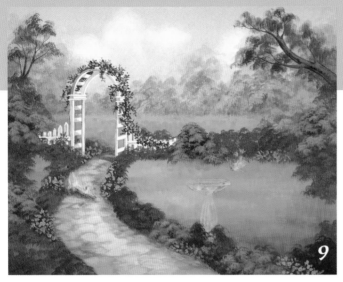

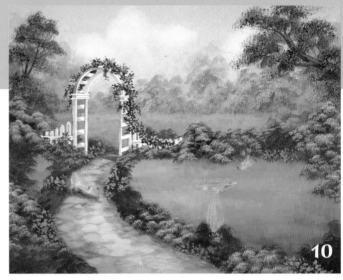

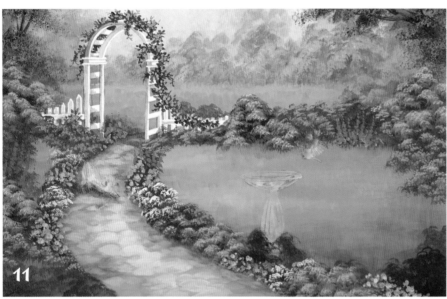

Step 9: Detail Trees, Add Flowers

Shade and detail the trees with Burnt Umber and the no. 3 round. Mix Butler Magenta + Coastal Blue (2:1) and stipple purple blossoms with the no. 8 filbert. Add red flowers with Red Light + Sunny Yellow (1:1).

Step 10: Highlight Flowers, Trees

Brush mix Titanium White into the flower mixes and stipple lighter blossoms. Sponge more leaves onto the trees with the sea sponge and Sap Green. Add lighter leaves with Apple Orchard.

Step 11: Add Blue and Yellow Flowers

Paint blue flowers with the no. 3 round and Brilliant Ultramarine + Titanium White (2:1). Dot yellow flowers with Sunny Yellow. Stipple Titanium White blossoms with the no. 8 filbert.

Step 12: Paint Birdbath, Add Roses

Uncover the birdbath. Basecoat it with Titanium White + Raw Sienna + Payne's Gray (2:1:touch), using the no. 6 round.

Dot roses on the arch, and in the very foreground add magenta flowers with Parisian Pink + Red Light (1:1) and the no. 3 round. Add more leaves with Sap Green and Apple Orchard.

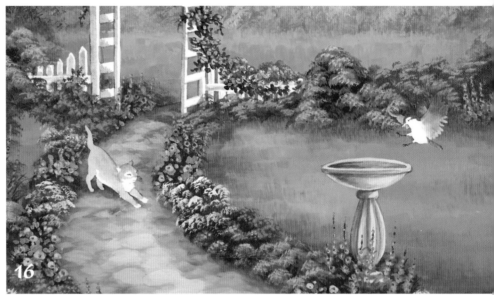

Step 13: Detail Birdbath, Highlight Flowers

Mix Burnt Umber + Payne's Gray (1:1), dilute until thin and transparent and begin shading the birdbath with the no. 3 round.

Brush mix Titanium White into all the flowers' base colors and add highlights.

Step 14: Detail Flowers, Birdbath

Add flower stems with Sap Green and the no. 0 round. Paint white daisies with Titanium White. Add more grass around the flower borders with thin Sap Green and the no. 12 flat.

Glaze more shading on the birdbath with diluted Raw Sienna + Burnt Umber (1:1), using the no. 3 round.

Step 15: Detail Birdbath

Dot Raw Sienna centers into the yellow, white and blue flowers. Finish detailing the birdbath with the Burnt Umber + Payne's Gray shading mixture from Step 13 and paint blue flowers overlapping it. Uncover the cat and bird.

Step 16: Paint Cat, Bird

Retransfer details on the cat and bird as necessary. Paint the bird with the Raw Sienna + Burnt Umber mixture from Step 14 and the no. 0 round.

Paint the cat with a diluted wash of the Burnt Umber + Payne's Gray mixture from Step 13. (See page 19 for more ideas on how to paint the cat.) Draw in the bird's eye and legs with the sharp pencil.

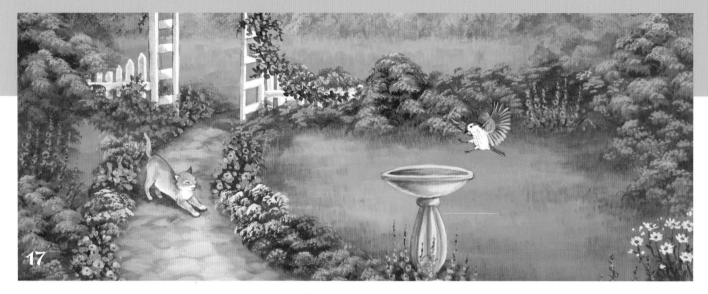

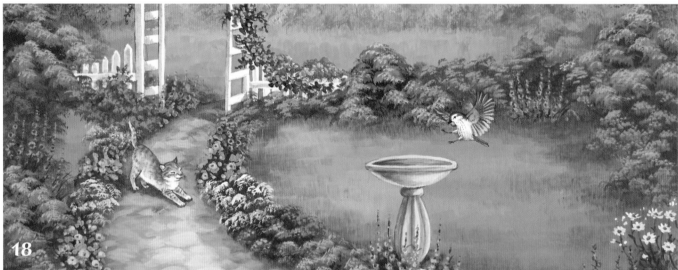

Step 17: Detail Animals

Begin shading the cat with more washes of the Burnt Umber + Payne's Gray mixture. Detail the bird with the same mix, using it undiluted. Highlight with Titanium White + Raw Sienna (1:touch).

Step 18: Detail Animals

With the no. 0 round, add glazes of Raw Sienna to the bird. Detail the cat with the Burnt Umber + Payne's Gray mixture. Add touches of Titanium White where necessary. The nose and inside the ear are painted with the Red Light + Sunny Yellow mixture from Step 9.

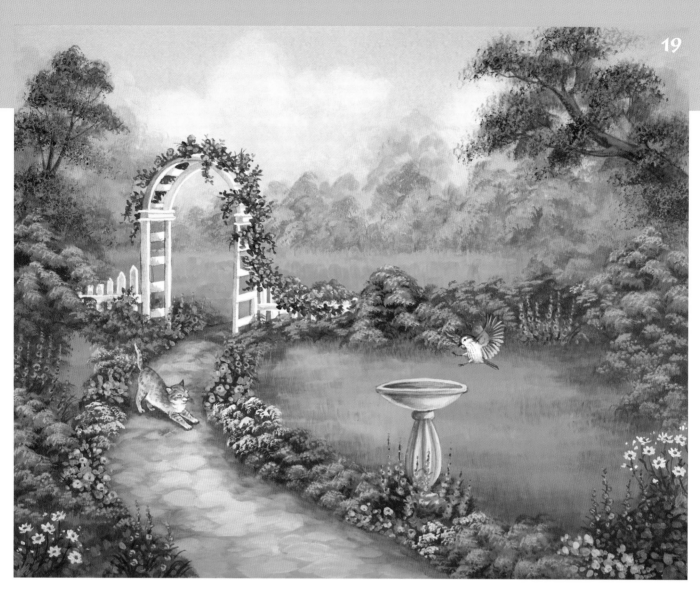

Step 19: Add Final Glazes

Finally, with the no. 3 round, glaze a few more Burnt Umber shadows
on the path, and add delicate glazes of Red Light + Sunny Yellow (1:1)
to the bottom of the clouds. Add touches of Titanium White to soften
the clouds.

Sunlit Fields

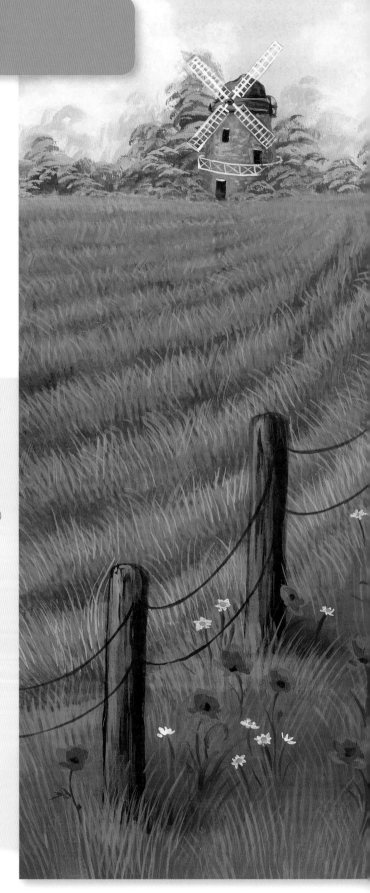

TRADITIONAL WINDMILLS ARE COMMON IN MANY
EUROPEAN COUNTRIES, NOT JUST HOLLAND. IN
BYGONE TIMES, THE MILLER WAS ONE OF THE
WEALTHIEST MEN IN THE VILLAGE, AS EVERYONE HAD
TO PAY TO HAVE THEIR GRAIN GROUND INTO FLOUR.
IN THIS PAINTING, I TRIED TO CREATE THE FEEL
OF A WARM SUMMER DAY AND AN OLD-FASHIONED
FARMER'S FIELD.

MATERIALS LIST

SURFACE
12" × 16" (30cm × 41cm) Canson Montval cold press watercolor paper

BRUSHES
¾-inch (19mm) wash; nos. 0, 3 and 6 rounds; no. 8 filbert; ⅜-inch (10mm)
Aqualon Wisp, series R2735

PLAID FOLKART ACRYLIC PAINT
Baby Blue, Basil Green, Cayman Blue, Fresh Foliage, Mint Green,
Soft Apple

PLAID FOLKART ARTIST'S PIGMENTS
Burnt Umber, Hooker's Green Dark, Payne's Gray, Raw Sienna,
Raw Umber, Red Light, Sap Green, Titanium White, Yellow Light,
Yellow Ochre

OTHER SUPPLIES
drafting tape (not masking tape), facial tissue, graphite transfer paper,
masking fluid, sharp pencil or stylus

PATTERN

This pattern may be hand traced or photocopied for personal use only. Enlarge at 200% on a photocopier to bring it up to full size.

PREPARE FOR PAINTING

Tape off an 11" × 14" (28cm × 36cm) area on your paper, using the drafting tape. Transfer the horizon line, windmill (excepting the sails) and fence posts with the graphite transfer paper and a sharp pencil or stylus (see page 10). Protect the windmill and posts with masking fluid and let dry thoroughly (see page 11).

Color Mixes

Red Light + Yellow Light + Titanium White (2:1:1)

Yellow Light + Yellow Ochre + Titanium White (2:1:1)

Yellow Ochre + Titanium White (1:1)

Sap Green + Yellow Light (1:touch)

Sap Green + Fresh Foliage (2:1)

Basil Green + Mint Green (2:1)

Sap Green + Burnt Umber (1:1)

Baby Blue + Cayman Blue (1:1)

Payne's Gray + Titanium White (2:1)

Burnt Umber + Payne's Gray (1:1)

Burnt Umber + Titanium White (1:1)

Titanium White + Burnt Umber (2:1)

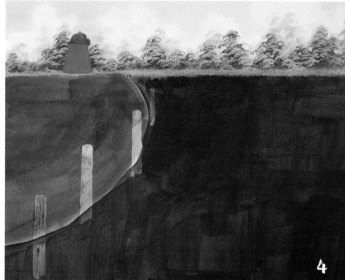

Step 1: Paint Sky

Wet the sky with clean water and the ¾-inch (19mm) wash brush, and paint a wash of Baby Blue + Cayman Blue (1:1). The paint should be diluted until it is quite thin and watery. Before the sky dries, blot out cloud shapes with a crumpled facial tissue (see page 14).

Step 2: Basecoat Distant Trees, Wheat Field

Dilute Baby Blue until it is thin and transparent and add a little shading to the clouds with the no. 8 filbert. Mix Basil Green + Mint Green (2:1) and pat in distant trees, still using the no. 8 filbert. Dilute Raw Umber to an inky consistency and paint the field with the ¾-inch (19mm) wash brush.

Step 3: Basecoat Field of Flowers

Paint the field with Hooker's Green Dark and the ¾-inch (19mm) wash brush. Mix Sap Green + Fresh Foliage (2:1) and pat in some darker trees in the distance with the no. 8 filbert. Add a little Hooker's Green Dark along the horizon line. Paint the lighter grass line with Soft Apple.

Step 4: Basecoat Windmill

Stipple Soft Apple onto the distant tress, still using the no. 8 filbert. Remove the masking fluid from the windmill. Mix Payne's Gray + Titanium White (2:1) and basecoat the bottom part of the mill with the no. 6 round brush. Paint the top with Burnt Umber + Titanium White (1:1).

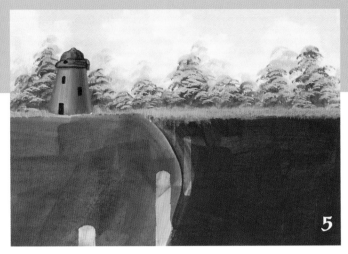

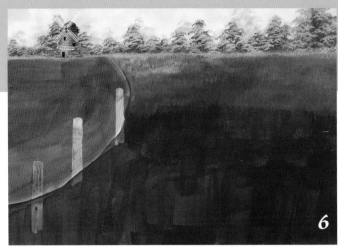

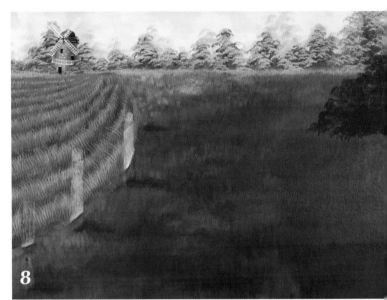

Step 5: Shade, Highlight Windmill

Brush mix more Payne's Gray into the windmill basecoat mix and shade the mill with the no. 3 round. Add more Titanium White to the mix for highlights. Mix Burnt Umber + Payne's Gray (1:1). Dilute with water to shade the top of the mill, and use the mixture full strength for details including the windows and door. Highlight the top by adding more Titanium White to its basecoat mix.

Step 6: Detail Windmill, Grass

Paint the sails and mill details with Titanium White and the no. 0 round. The bushes around the mill are added using the same techniques as the distant trees in Steps 2–4. Starting at the horizon, add more grass with vertical strokes of the no. 8 filbert and Fresh Foliage, Soft Apple and various brush mixes of Sap Green + Fresh Foliage.

Step 7: Add Rows of Wheat, More Grass

With the ⅜-inch (10mm) Aqualon wisp, paint the rows on the hay field with Yellow Ochre. Make your brushstrokes longer as you move down the painting. Continue adding grass in the flower field. The fence shadows are Hooker's Green Dark.

Step 8: Detail Wheat Field

Add strokes of Raw Sienna and diluted Burnt Umber to the bases of each row in the wheat field, using the ⅜-inch (10mm) wisp. Mix Yellow Ochre + Titanium White (1:1) and add light strokes to the top of each row. Lay in the bush on the right with Hooker's Green Dark and the no. 8 filbert.

TIP

This painting uses a wisp brush, which is a sort of modified rake brush with separated bristles. If you do not have a wisp, you can paint the strokes individually with the no. 3 round brush.

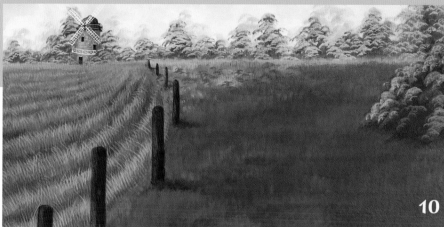

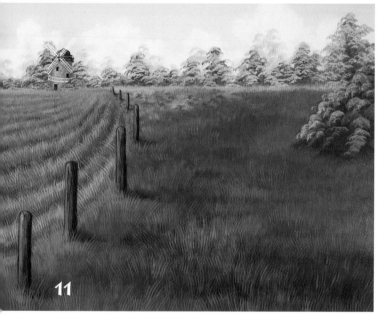

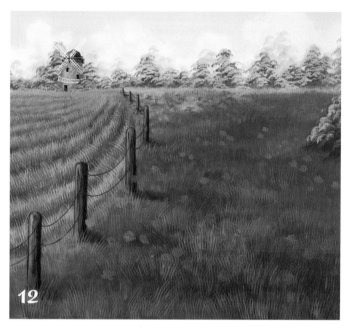

Step 9: Detail Bush, Begin Poppies

Stipple foliage on the bush with Fresh Foliage and the no. 8 filbert. Add highlights with Soft Apple. Shade under the bush with Sap Green + Burnt Umber (1:1). Paint a very thin, transparent wash of Fresh Foliage over the wheat field in the background. Pat in distant poppies with the no. 8 filbert and Red Light + Yellow Light + Titanium White (2:1:1).

Step 10: Basecoat Posts, Detail Bush, Windmill

Remove the mask from the posts and paint with Burnt Umber and the no. 6 round. Shade with the Burnt Umber/Payne's Gray mixture from Step 5.

Paint a very thin wash of Sap Green across the bush on the right. Mix Titanium White + Burnt Umber (2:1) and add dotted texture to the windmill with the no. 3 round.

Step 11: Highlight Posts, Add Tall Grass

Highlight the posts with Titanium White + Burnt Umber (2:1), using the no. 3 round. Paint a thin wash of Raw Sienna over the highlights when dry. Use the ⅜-inch (10mm) wisp brush to add tall grasses with Yellow Ochre, Raw Sienna and Fresh Foliage. Your brushstrokes should be longer in the foreground.

Step 12: Detail Fence, Paint Poppies

With the no. 3 round and Payne's Gray, draw the wire fence between the posts. Paint more poppies with the Red Light + Yellow Light + Titanium White mixture from Step 9 and the no. 3 round. The poppies should gradually get bigger as you move down the page.

TIP

When painting grasses, make sure to vary the length and direction of your brushstrokes for a more natural appearance.

44

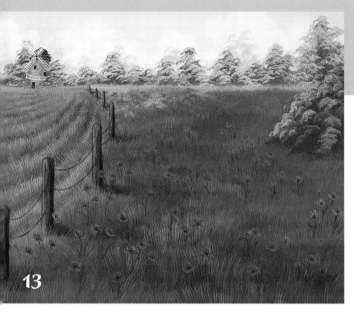

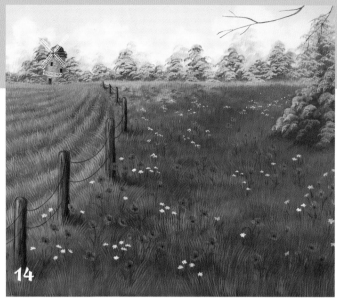

Step 13: Detail Poppies

Add darker red swirls and details to the pop-pies with Red Light, still using the no. 3 round. Paint the dark centers with Payne's Gray. The stems are Hooker's Green Dark, painted with the no. 0 round. Paint a thin Yellow Light wash over the wheat field and foreground grass to add warmth and brightness.

Step 14: Add White Flowers, Foreground Branch

With the no. 3 round, dot in white flowers with Titanium White, and yellow flowers with Yellow Light + Yellow Ochre + Titanium White (2:1:1). Add more Hooker's Green Dark stems.

Transfer the tree branch with the graphite paper and paint with Burnt Umber and the no. 3 round.

Step 15: Detail Flowers, Branch

Dot in the centers of the white flowers with Yellow Ochre, and the yellow flowers with Raw Sienna, then a smaller dot of Burnt Umber. Paint leaves on the branch with Sap Green + Yellow Light (1:touch) and Yellow Ochre and the no. 3 round. Add darker greens with Sap Green.

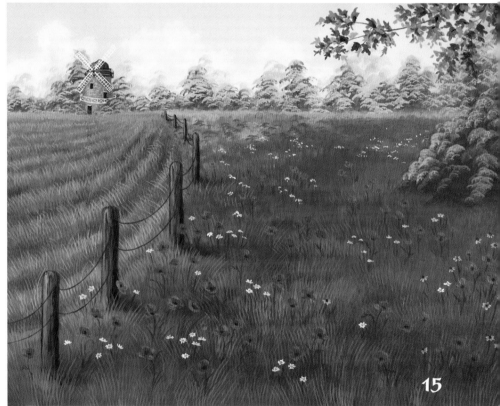

Woodland Way

This scene is based on a woodland path I saw while camping in the Rocky Mountains. I added drifts of wildflowers and flowering trees. The focus is on the sunlit bridge, so don't be afraid to let your foreground shadows get quite dark to enhance the effect.

MATERIALS LIST

SURFACE
12" × 16" (30cm × 41cm) Canson Montval cold press watercolor paper

BRUSHES
½-inch (13mm) and 1½-inch (38mm) wash; nos. 0, 2 and 5 round; nos. 2 and 8 flat; no. 8 filbert

PLAID FOLKART ACRYLIC PAINT
Baby Blue, Basil Green, Cayman Blue, Fresh Foliage, Lilac Love, Soft Apple

PLAID FOLKART ARTIST'S PIGMENTS
Burnt Umber, Butler Magenta, Cobalt Blue, Dioxazine Purple, Hauser Green Dark, Napthol Crimson, Raw Sienna, Sap Green, Titanium White, Van Dyke Brown, Yellow Light, Yellow Ochre

OTHER SUPPLIES
drafting tape (not masking tape), graphite transfer paper, masking fluid, sea sponge, sharp pencil or stylus, white transfer paper

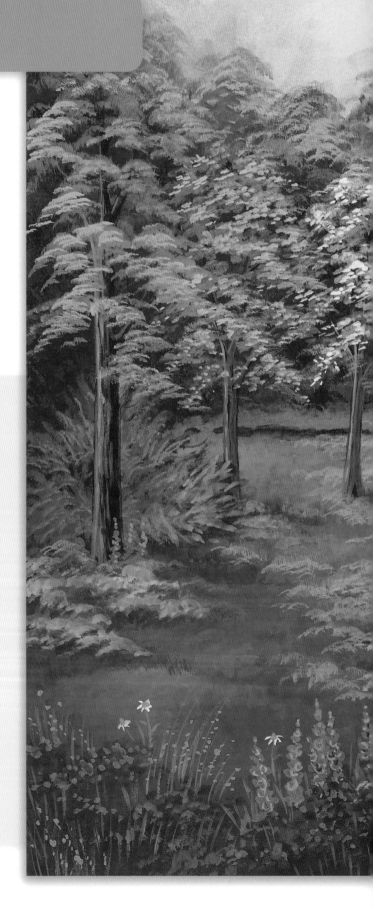

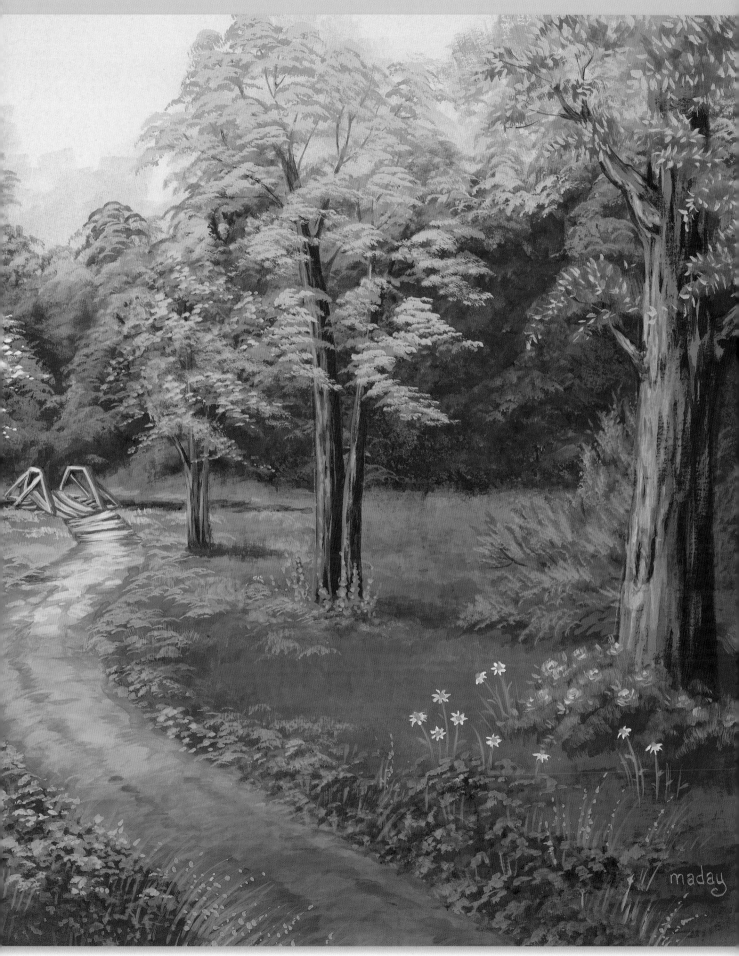

PATTERN

This pattern may be hand traced or photocopied for personal use only. Enlarge at 200% on a photocopier to bring it up to full size.

PREPARE FOR PAINTING

Use the drafting tape to mark off an 11" × 14" (28cm × 36cm) area on the paper. To begin, transfer only the bridge, path and horizon line with the graphite transfer paper and a sharp pencil or stylus (see page 10). Use masking fluid to cover and protect the bridge (see page 11).

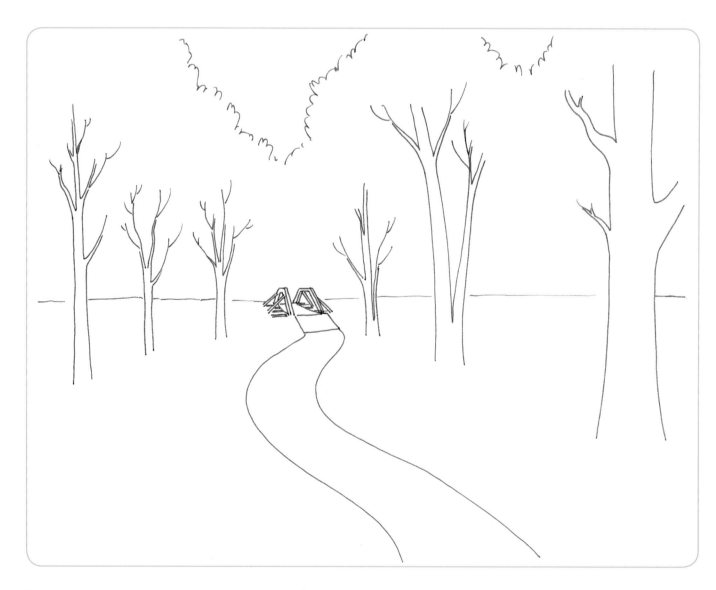

COLOR MIXES

Butler Magenta + Napthol Crimson (1:1)

Butler Magenta + Titanium White (1:1)

Yellow Ochre + Titanium White (1:1)

Fresh Foliage + Yellow Light (2:1)

Sap Green + Titanium White (1:generous touch)

Burnt Umber + Hauser Green Dark (1:1)

Baby Blue + Titanium White (1:1)

Dioxazine Purple + Lilac Love (2:1)

Lilac Love + Titanium White (1:1)

Van Dyke Brown + Dioxazine Purple (1:1)

Raw Sienna + Van Dyke Brown + Titanium White
(1:1: touch)

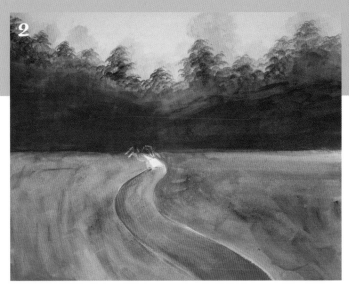

Step 1: Paint Sky, Foliage Washes

Wet the sky with clean water and the 1½-inch (38mm) wash brush and paint a thin wash of Baby Blue + Cayman Blue (1:touch) (see page 13). It doesn't need to be a completely smooth wash, as most of it will be covered with trees. When dry, loosely lay in the distant trees with the ½-inch (13mm) wash brush and diluted Basil Green.

Step 2: Basecoat Grass, Tree Line, Path

Lay in the grass with Hauser Green Dark and the 1½-inch (38mm) wash brush. Stipple the edge of the tree line with the no. 8 filbert and Hauser Green Dark, and fill in below with the ½-inch (13mm) wash brush. Paint the path with Raw Sienna and the no. 5 round brush.

Step 3: Place Bushes

Mix Burnt Umber + Hauser Green Dark (1:1) and pat this dark green over the bottom of the bushes with the sea sponge (don't go all the way to the top edges). Next, stipple in lighter foliage with the no. 8 filbert and Sap Green and Fresh Foliage (see page 13). Use Soft Apple for the lightest areas at the edges.

Step 4: Place Distant Bank, Grass

With the no. 8 flat and Burnt Umber, paint the area under the bridge. Add a Yellow Ochre strip along the top. Mix Fresh Foliage + Yellow Light (2:1) and paint another strip above the Yellow Ochre, blending it up into the background bushes. Add more grass with Fresh Foliage and short vertical strokes of the no. 8 flat.

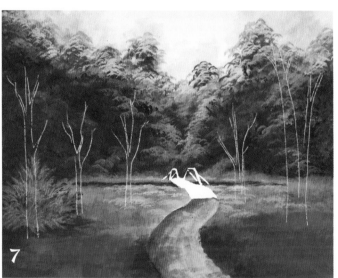

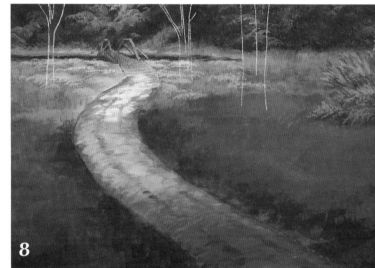

Step 5: Paint Midground, Shade Path

Tap in the midground bushes with Hauser Green Dark and the no. 8 filbert. Add a little Titanium White to the Fresh Foliage + Yellow Light mixture from Step 4 and add lighter patches of grass. Shade the path with diluted Van Dyke Brown and the no. 8 flat. Blend with clean water.

Step 6: Add Shading, More Foliage, Grass

Shade under the bushes and along the path with the Burnt Umber + Hauser Green Dark mixture from step 3, using the no. 8 flat. Mix Sap Green + Titanium White (1:generous touch) and add foliage by tapping diagonal strokes with the no. 8 filbert. Use the same mixture to add more grass.

Step 7: Detail Bushes, Transfer Trees

Tap in highlights on the bushes with the Fresh Foliage + Yellow Light mixture and the no. 8 filbert. Add little twigs with the no. 2 round and Burnt Umber. When dry, transfer all the trees, except the largest, with the white transfer paper. Remove the masking fluid from the bridge.

Step 8: Basecoat Bridge, Shade Path

Basecoat the bridge with Raw Sienna and the no. 2 round. Mix Yellow Ochre + Titanium White (1:1) and paint the light texture on the patch with curved strokes of the no. 8 flat. Add more Titanium White to the mix for the lightest patches. For the dark shading, mix Raw Sienna + Van Dyke Brown + Titanium White (1:1:touch). Add more Van Dyke Brown as you move to the darkest area at the bottom of the page.

TIP

Sometimes when you mix Titanium White with other colors, your colors look a little dull and gray. If this happens, try diluting Yellow Ochre with clean water and painting a very thin glaze over the dull area. This can help add brightness and warmth to the colors.

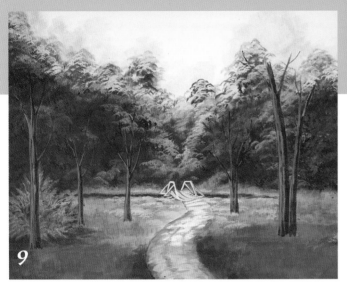

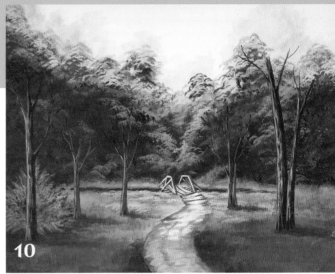

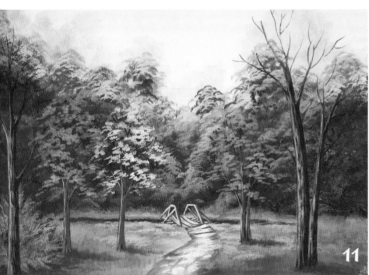

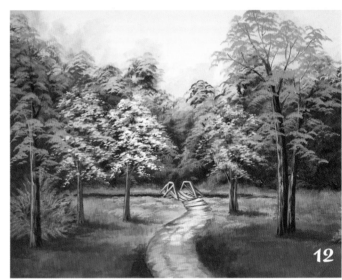

Step 9: Paint Trees, Bridge

Paint the tree trunks with Burnt Umber and the no. 2 round. Add streaks of Burnt Umber + Titanium White (1:1) along their left sides.

Use Titanium White + Yellow Ochre (2:1) to paint the boards of the bridge with the no. 2 round.

Step 10: Detail Trees, Bridge

Add cast shadows coming from the trees onto the grass with the no. 8 flat and the Hooker's Green Dark + Burnt Umber mixture. Highlight the tree trunks with the no. 2 round and Yellow Ochre + Titanium White mixture. Shade the trunks with Van Dyke Brown.

Detail the bridge with Burnt Umber and highlight with Titanium White.

Step 11: Add Blooms to Trees

Add delicate twigs to the trees with the no. 0 round and Burnt Umber. Mix Baby Blue + Titanium White (1:1) and tap blossoms on the tree with the no. 2 flat. Add pink blossoms to the other two trees with Butler Magenta.

Step 12: Detail Trees

Dot Titanium White blossoms onto the Baby Blue + Titanium White blooms with the no. 2 flat. Mix Butler Magenta + Titanium White (1:1) and dot the mixture onto the pink trees. Add leaves to all four trees with the Fresh Foliage + Yellow Light mixture.

Paint leaves on the front two trees with Fresh Foliage and the no. 8 filbert.

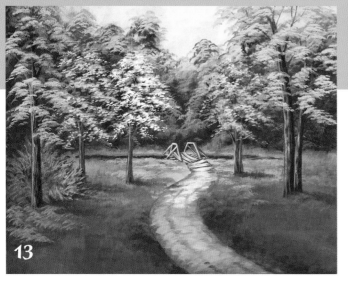

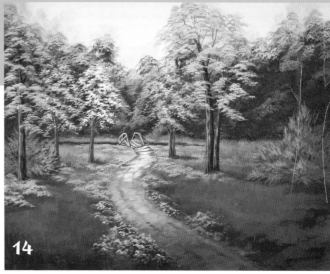

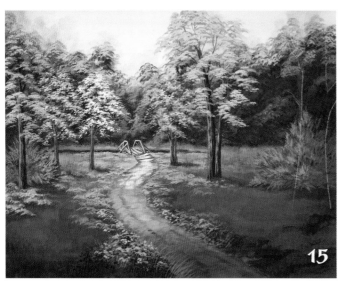

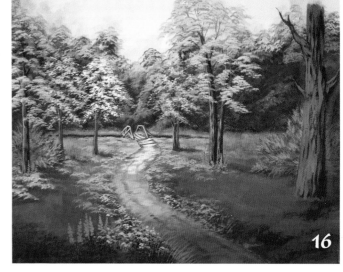

Step 13: Detail Trees, Add Flowers

Add lighter foliage to the green trees with Soft Apple and the no. 8 filbert. Extend the bush on the left to overlap the pink tree. Stipple drifts of pink and purple flowers on the ground with the no. 8 filbert and Lilac Love and Butler Magenta.

Step 14: Add More Flowers

Stipple lighter flowers with Lilac Love + Titanium White (1:1) and Butler Magenta + Titanium White (1:1). Transfer the remaining tree trunk. Continue adding pink and purple flowers, switching to the no. 2 flat to dot them in as you move closer to the foreground.

Step 15: Add More Blooms

Add a few yellow blossoms with Yellow Ochre + Titanium White (2:1) and the no. 8 filbert. Paint some leaves and grasses in the foreground with Fresh Foliage and the no. 2 round brush. Mix Dioxazine Purple + Lilac Love (2:1) and dot in some darker purple flowers in the shaded areas with the no. 2 flat.

Step 16: Paint Large Tree, More Flowers

Paint the large tree trunk with Burnt Umber and the no. 5 round. Let dry, then add streaks of Burnt Umber + Titanium White (1:1) as you did on the other trees. Mix Cobalt Blue + Titanium White (1:touch) and Butler Magenta + Napthol Crimson (1:1) and dot in flower spikes with the no. 2 round. Continue adding dark purple flowers.

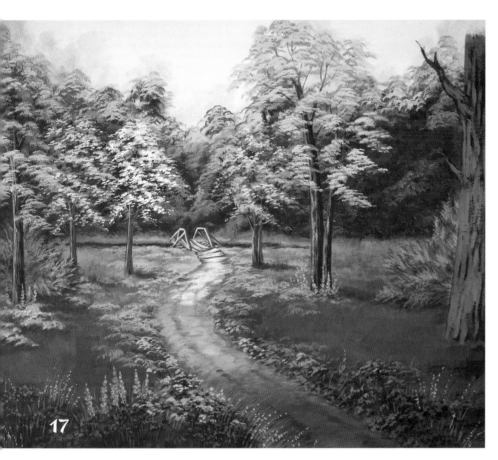

Step 17: Highlight Flowers

Continue adding grass blades with Fresh Foliage and the no. 2 round. Dot the tallest blades with blue flowers made from Cobalt Blue + Titanium White (1:1). Use this mix to highlight the other blue flowers. Add Titanium White to the pink flower mix for highlights. Highlight the dark purple flowers with Lilac Love.

Step 18: Detail Large Tree

Highlight the large tree with the Yellow Ochre + Titanium White mixture from before, and shade with Van Dyke Brown + Dioxazine Purple (1:1), using the no. 2 round. Paint in the shape of a bush with the no. 8 filbert and the Hooker's Green Dark + Burnt Umber mixture.

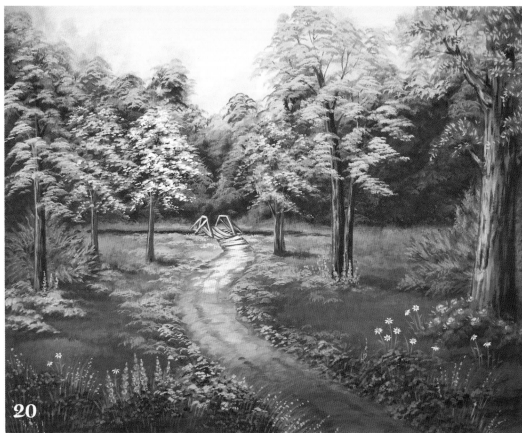

Step 19: Paint Foliage, Daisies

Add foliage to the tree and bush with the no. 8 filbert and Fresh Foliage and Sap Green. Add daisies with the no. 2 round, using Fresh Foliage for the stems, Titanium White for the petals and Yellow Ochre for the centers.

Step 20: Detail Bush

With the no. 2 flat, paint blossoms on the bush with the Butler Magenta + Napthol Crimson mixture. Add Titanium White to the mixture for highlights. Add little leaves with Fresh Foliage + Yellow Light + Titanium White (1:1:touch) and the no. 2 round. Add more leaves to the tree with Soft Apple, still using the no. 2 round, and little twigs with Burnt Umber.

Through The Gate

This is a nice, intimate scene, and I wanted to create the feeling of soft morning light. I chose a blue gate, but you could substitute another color such as red or green so the painting matches the decor in your home.

MATERIALS LIST

SURFACE
12" × 16" (30cm × 41cm) Canson Montval cold press watercolor paper

BRUSHES
¾-inch (19mm) wash; nos. 3 and 6 rounds; nos. 4 and 8 filbert

PLAID FOLKART ACRYLIC PAINT
Apple Orchard, Bright Baby Pink, Forest Moss, Green Forest, Light Periwinkle, Soft Apple, Sunny Yellow

PLAID FOLKART ARTIST'S PIGMENTS
Alizarin Crimson, Brilliant Ultramarine, Dioxazine Purple, Payne's Gray, Raw Sienna, Raw Umber, Red Light, Sap Green, Titanium White, Van Dyke Brown, Yellow Light

OTHER SUPPLIES
drafting tape (not masking tape), graphite transfer paper, masking fluid, sea sponge, sharp pencil or stylus, white transfer paper

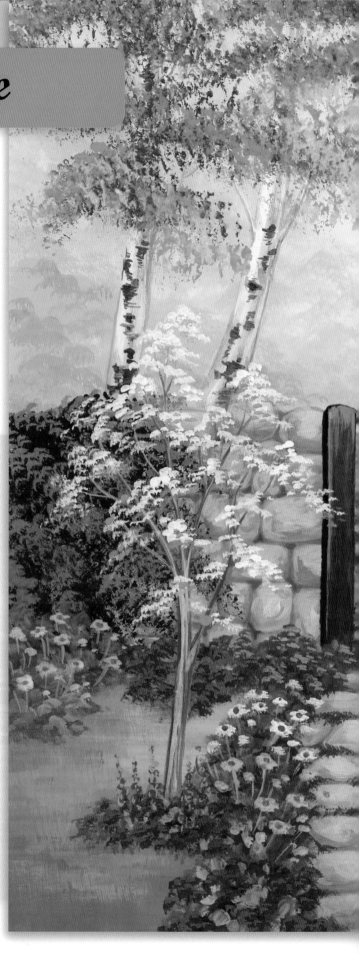

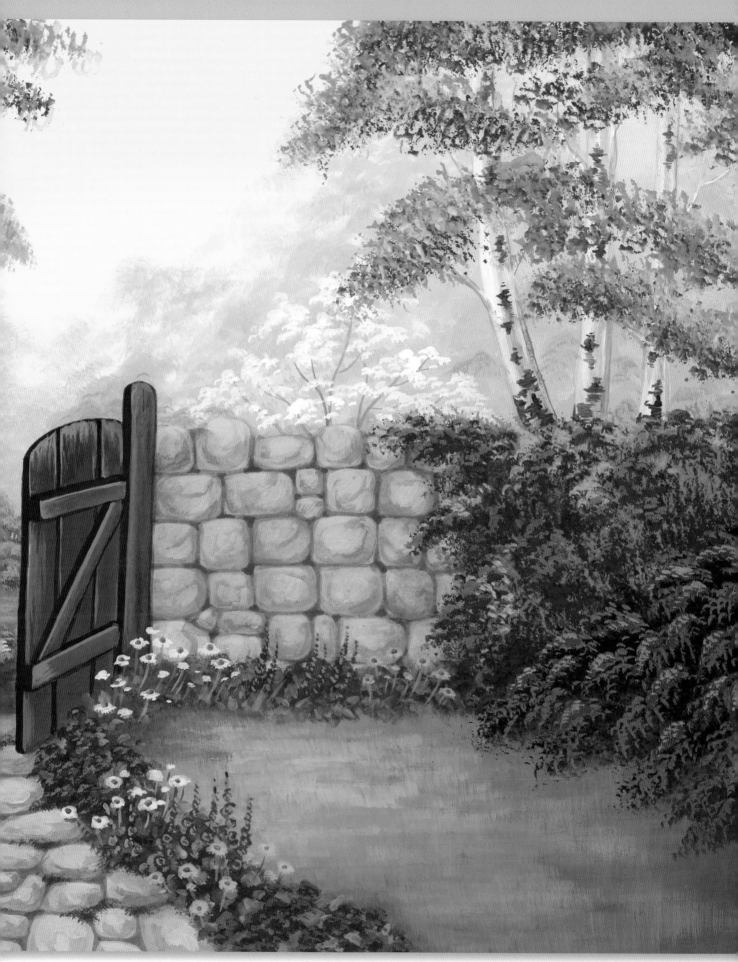

PATTERN

This pattern may be hand traced or photocopied for personal use only. Enlarge at 200% on a photocopier to bring it up to full size.

PREPARE FOR PAINTING

Tape off a 11" × 14" (28cm × 36cm) area on your paper with the drafting tape. Use graphite paper and a sharp pencil or stylus to transfer the gate and the outline of the wall and the path (see page 10). You'll transfer the rest of the design later. Cover the gate and gateposts with masking fluid (see page 11). Let dry.

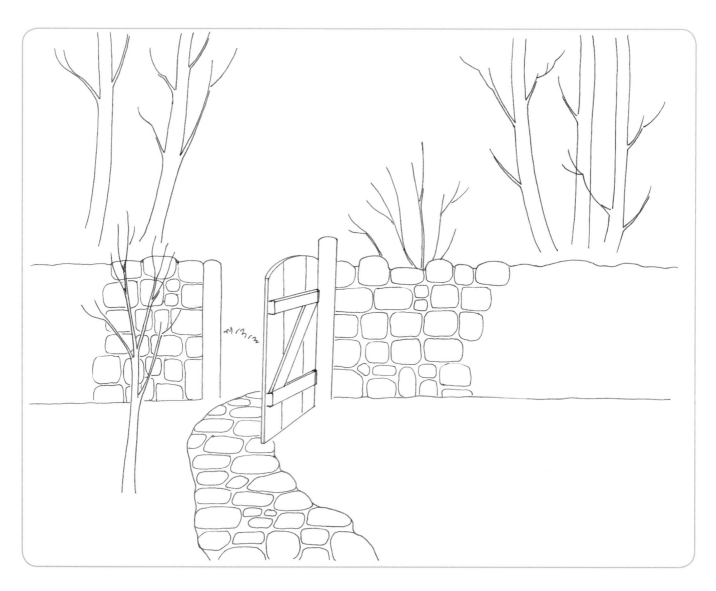

COLOR MIXES

Alizarin Crimson + Red Light (1:1)

Bright Baby Pink + Titanium White (1:1)

Red Light + Sunny Yellow + Titanium White (1:1:touch)

Sunny Yellow + Titanium White (1:1)

Soft Apple + Sap Green (2:1)

Titanium White + Apple Orchard (2:1)

Sap Green + Apple Orchard (1:1)

Green Forest + Titanium White (1:1)

Brilliant Ultramarine + Payne's Gray (1:1)

Light Periwinkle + Titanium White (1:1)

Raw Umber + Raw Sienna (1:1)

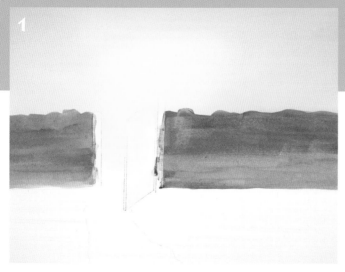

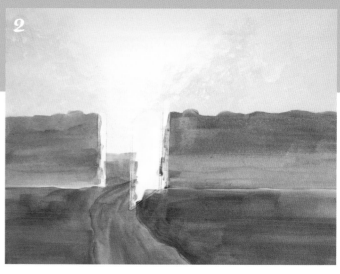

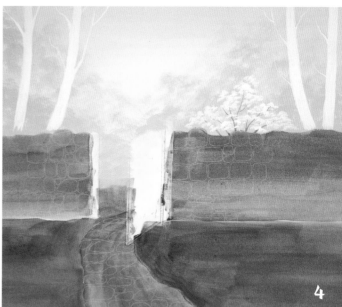

Step 1: Paint Sky, Wall Washes

Wet the sky with the ¾-inch (19mm) wash brush. Paint a wash with Sunny Yellow + Titanium White (1:1) (see page 13). While the paint is still wet, paint a little Titanium White in the center of the sky and Bright Baby Pink at the sides, and blend. Paint the wall with Raw Umber, diluted until watery.

Step 2: Basecoat Path, Grass, Distant Foliage

Paint the path with the diluted Raw Umber and the no. 6 round. Use the ¾-inch (19mm) wash brush to paint the grass with Sap Green. Pat in distant foliage with the no. 8 filbert and Light Periwinkle + Titanium White (1:1).

Step 3: Add More Foliage

Stipple more foliage with Soft Apple and Bright Baby Pink + Titanium White (1:1), still using the no. 8 filbert (see page 13). Use the paint quite dry for a softer effect. Lightly transfer the trees with the graphite paper and the stones in the wall and path with the white transfer paper.

Step 4: Paint Trees

Paint the small tree branches with thin Raw Umber and the no. 3 round. Stipple blossoms with Light Periwinkle + Titanium White (1:1) and the no. 4 filbert. Stipple Titanium White blossoms over the top. Paint the birch trunks with Titanium White and the no. 6 round.

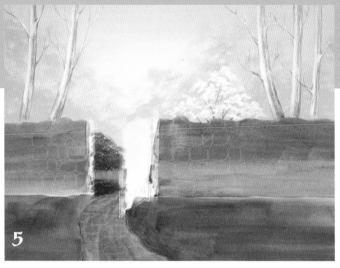

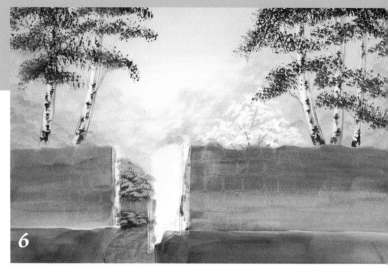

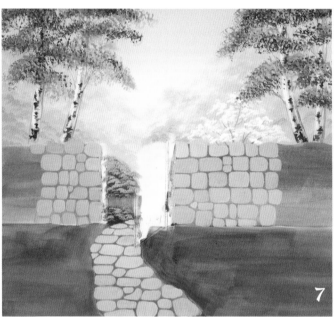

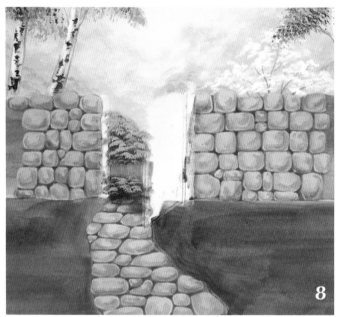

Step 5: Shade Birches

Mix Raw Umber + Raw Sienna (1:1), dilute until thin and transparent, and shade the birch trees with the no. 3 round. Stipple shrubbery through the gate with Sap Green and the no. 8 filbert.

Step 6: Add Foliage

Add more foliage to the background with Soft Apple + Sap Green (2:1) and the no. 8 filbert. Detail the birch trees with Van Dyke Brown and the no. 3 round. Stamp some foliage with Sap Green and the sea sponge (see page 15).

Step 7: Detail Foliage, Paint Stones

Stamp lighter leaves with Apple Orchard, and add a few more with Sunny Yellow. Mix Titanium White + Raw Umber + Raw Sienna (3:1:1) and paint the stones with the no. 6 round.

Step 8: Shade, Detail Stone

Touch up between the stones with the Raw Umber + Raw Sienna mixture from step 5 and the no. 3 round. Dilute the mixture with water until it is very thin, and glaze shading on the stones. Paint a darker shadow on the path by the gate with thin Van Dyke Brown.

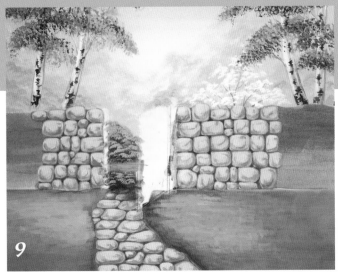

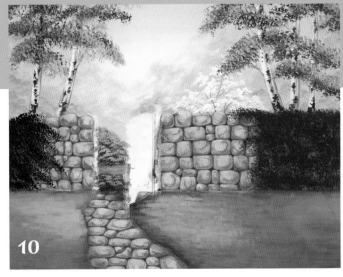

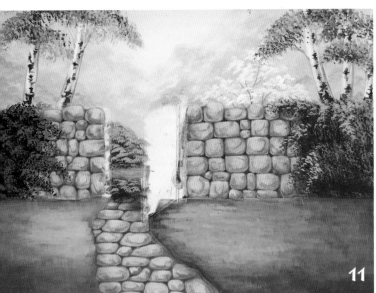

Step 9: Highlight Stone, Paint Grass

Highlight the stones with Titanium White + Raw Sienna (1:touch) and the no. 3 round. Paint the grass with short vertical strokes of the ¾-inch (19mm) wash brush and Apple Orchard. Add lighter grass with Titanium White + Apple Orchard (2:1).

Step 10: Glaze Stones, Add Foliage

Paint glazes over the stones with Forest Moss, Raw Sienna and Payne's Gray, using the no. 6 round. Sponge Sap Green along the right side of the wall and Green Forest on the left side.

Step 11: Detail Foliage on Wall

Sponge Apple Orchard onto the Sap Green foliage on the wall. Add lighter leaves with Apple Orchard + Titanium White (1:1) and the no. 4 filbert. Add lighter leaves on the left with Green Forest + Titanium White (1:1). Add darker grass with Sap Green + Apple Orchard (1:1).

Step 12: Detail Path, Basecoat Gate

Stipple Sap Green along the path and between the stones with the no. 8 filbert. Sponge in a Green Forest bush on the right.

Uncover the gate and posts and paint them with Brilliant Ultramarine + Titanium White (1:touch) and the no. 6 round.

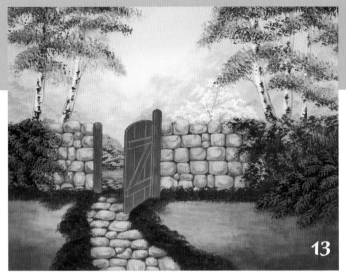

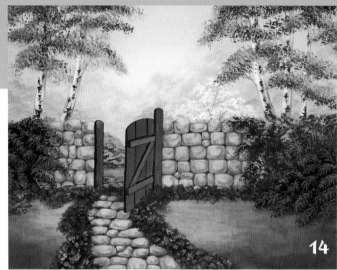

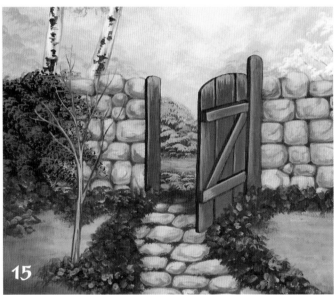

Step 13: Add Blooms, Transfer Details on Gate

Mix Alizarin Crimson + Red Light (1:1) and pat blossoms with the no. 4 filbert. Add lighter foliage to the bush with Green Light + Titanium White (1:1). Transfer the details of the gate with the white transfer paper.

Step 14: Detail Border, Gate

Paint loose leaf shapes in the flower border with the no. 4 filbert and Apple Orchard and Sap Green + Apple Orchard (1:1).

Mix Brilliant Ultramarine + Payne's Gray (1:1) and paint dark details on the gate and posts with the no. 3 round.

Step 15: Paint Foreground Tree, Highlight Gate

Transfer the foreground tree. Paint the tree with Titanium White + Raw Umber (2:1) and shade with Raw Umber, using the no. 3 round. Extend the flower border under the tree. Mix Titanium White + Brilliant Ultramarine (2:1) and highlight the gate with the no. 3 round.

Step 16: Add Blossoms

Tap Titanium White blossoms and Apple Orchard leaves on the tree with the no. 4 filbert. Add light red blossoms to the wall with Red Light + Sunny Yellow + Titanium White (1:1:touch).

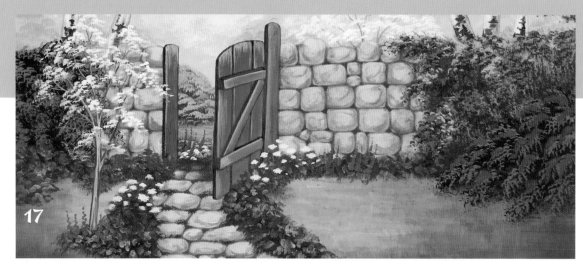

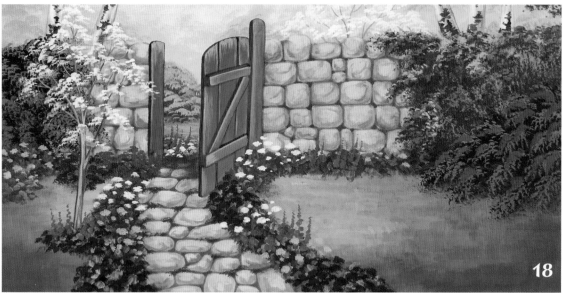

Step 17: Add Blue, Purple Flowers

With the no. 3 round, dot in blue flowers with the Brilliant Ultramarine + Titanium White mix (1:touch). Add white blossoms with Titanium White, and purple flowers with Dioxazine Purple + Titanium White (1:generous touch) and the no. 4 filbert.

Step 18: Add More Blooms

Add red blossoms as before. Paint yellow flowers with Yellow Light + Titanium White (1: touch) and the no. 4 filbert. Continue adding white and blue blossoms as before.

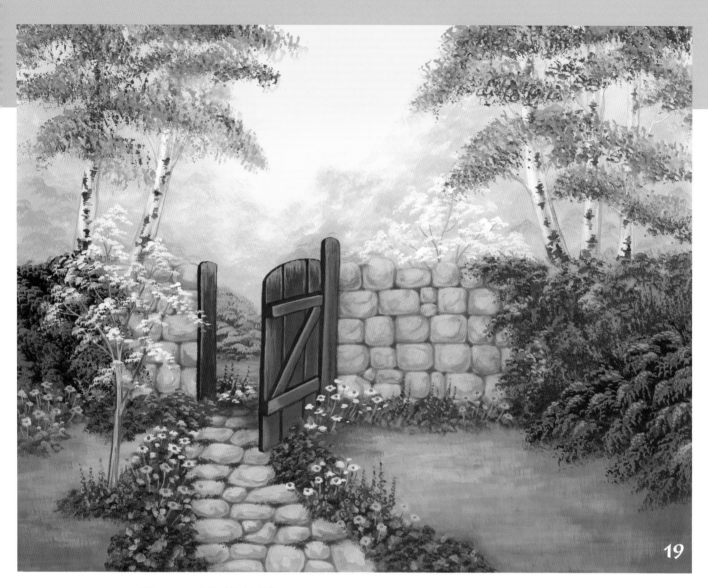

19

Step 19: Highlight Flowers

Highlight the flowers by brush mixing more Titanium White into their base colors. With the no. 3 round, dot centers into some flowers with Raw Sienna and add flower stems with Apple Orchard and Sap Green. Add more grass if desired.

Gazebo Garden

IN THIS PAINTING I TRIED TO CREATE THE FEELING OF DAPPLED SUNLIGHT IN A ROMANTIC GARDEN. MANY OF THE PAINTINGS IN THIS BOOK ARE BASED ON ACTUAL PLACES I HAVE VISITED, BUT THIS GENTLE GARDEN EXISTS ONLY IN MY IMAGINATION.

MATERIALS LIST

SURFACE
12" × 16" (30cm × 41cm) Canson Montval cold press watercolor paper

BRUSHES
¾-inch (19mm) wash; nos. 0, 3, and 6 round; nos. 4 and 8 filbert

PLAID FOLKART ACRYLIC PAINT
Apple Orchard, Basil Green, Coastal Blue, Light Peony, Light Periwinkle, Soft Apple, Sunny Yellow

PLAID FOLKART ARTIST'S PIGMENTS
Alizarin Crimson, Burnt Umber, Butler Magenta, Cobalt Blue, Payne's Gray, Raw Sienna, Raw Umber, Red Light, Sap Green, Titanium White, Yellow Ochre

OTHER SUPPLIES
brown colored pencil, drafting tape (not masking tape), graphite transfer paper, masking fluid, ruler, sea sponge, sharp pencil or stylus, white transfer paper

PATTERN

This pattern may be hand traced or photocopied for personal use only. Enlarge at 200% on a photocopier to bring it up to full size.

PREPARE FOR PAINTING

Tape off an 11" × 14" (28cm × 36cm) area on your watercolor paper. Use graphite transfer paper and a sharp pencil or stylus to transfer the gazebo, the horizon line and the foreground hollyhocks (see page 10). You'll transfer the rest later. Protect the gazebo and hollyhocks with masking fluid (see page 11). You can skip masking the latticework on the gazebo. Let the masking fluid dry thoroughly.

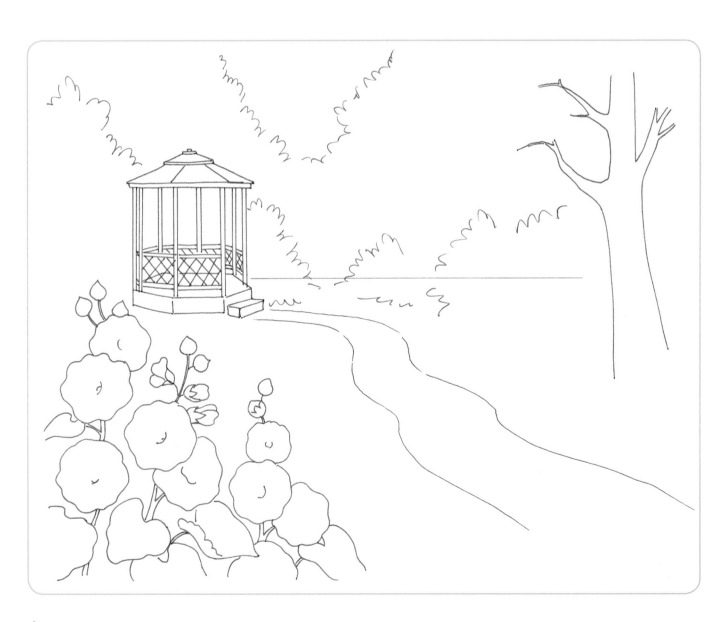

Color Mixes

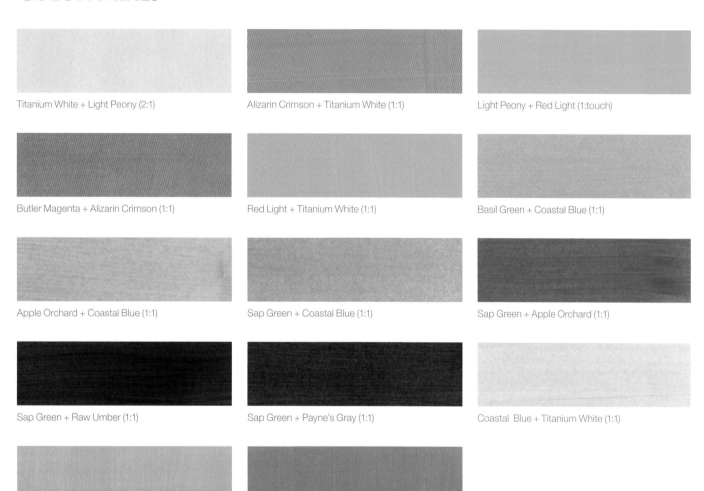

Titanium White + Light Peony (2:1)

Alizarin Crimson + Titanium White (1:1)

Light Peony + Red Light (1:touch)

Butler Magenta + Alizarin Crimson (1:1)

Red Light + Titanium White (1:1)

Basil Green + Coastal Blue (1:1)

Apple Orchard + Coastal Blue (1:1)

Sap Green + Coastal Blue (1:1)

Sap Green + Apple Orchard (1:1)

Sap Green + Raw Umber (1:1)

Sap Green + Payne's Gray (1:1)

Coastal Blue + Titanium White (1:1)

Titanium White + Burnt Umber (2:1)

Burnt Umber + Titanium White (1:1)

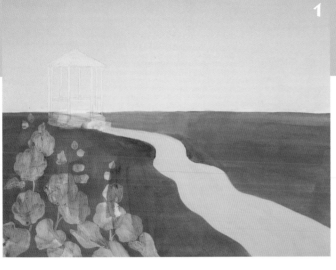

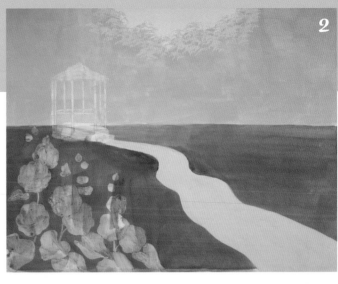

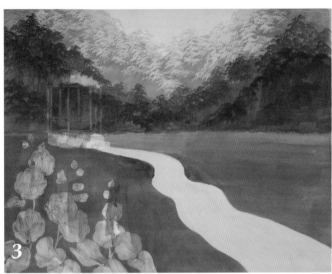

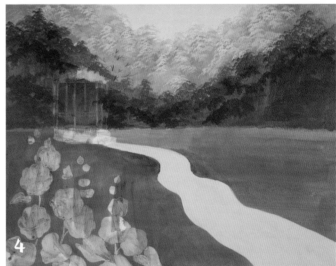

Step 1: Basecoat Sky, Grass, Path

Wet the sky with clean water and the ¾-inch (19mm) wash brush. Paint the sky with diluted Coastal Blue + Titanium White (1:1). Let dry, then paint the ground with Sap Green. Transfer the path and use the no. 6 round to paint it with Yellow Ochre + Titanium White (1:1)

Step 2: Lay in Background Foliage

With the no. 8 filbert, lay in the background trees with Basil Green + Coastal Blue (1:1). Use the ¾-inch (19mm) wash brush for the larger areas. Brush mix some Titanium White into the mix and stipple foliage along the top edges with the no. 8 filbert. (See page 21 for more instruction on painting background foliage.)

Step 3: Add More Foliage

Mix Sap Green + Coastal Blue (1:1) and stipple slightly darker trees in front of the previous trees. Add lighter foliage with Soft Apple. Stipple a row of even darker foliage with Sap Green. Fill in the larger areas with Sap Green and the ¾-inch (19mm) wash brush.

Step 4: Add Flowering Trees, Glaze Foliage

Pat in some Butler Magenta and Light Periwinkle with the no. 4 filbert. Paint tree branches with Raw Umber and the no. 0 round. Add darker green foliage with the no. 8 filbert and Sap Green + Raw Umber (1:1). Soften background foliage with glazes of Sap Green + Soft Apple (1:1).

TIP

Stippling can be hard on your brushes. Be sure to replace them when the chisel edge begins to get worn and frayed.

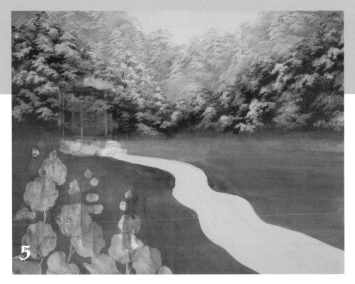

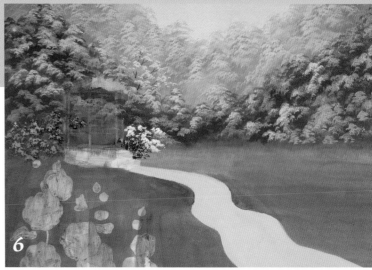

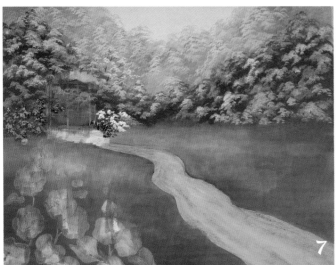

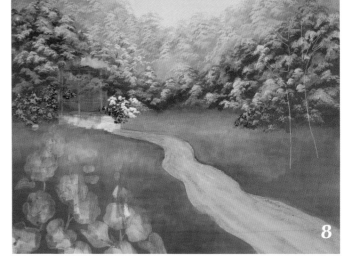

Step 5: Add Background Bushes

Mix Butler Magenta + Titanium White (1:1) and pat in the lighter pink on the tree with the no. 4 filbert. Mix Sap Green + Apple Orchard (1:1) and blend the grass into the bottom of the background bushes with the no. 8 filbert. Add lighter foliage to the bushes with Apple Orchard. Stipple the lightest foliage with Apple Orchard + Titanium White (1:1).

Step 6: Add Blooms

With the no. 4 filbert, stipple blossoms by the gazebo with Alizarin Crimson. Add more with the blue sky mix from Step 1. Add highlights with dots of the no. 3 round and Alizarin Crimson + Titanium White (1:1) and pure Titanium White. Stipple blue blossoms on the right with Light Periwinkle and the no. 8 filbert.

Step 7: Paint Grass

Brush mix various greens with combinations of Sap Green, Apple Orchard and Soft Apple and paint the grass with short vertical strokes of the ¾-inch (19mm) wash brush. Glaze Raw Umber over the path.

Step 8: Highlight Flowers, Add Bush

Mix Light Periwinkle + Titanium White (1:1) and add highlights to the periwinkle flowers on the right with the no. 8 filbert. Paint a Sap Green bush in front and add Alizarin Crimson flowers as before. Transfer the tree with the white transfer paper.

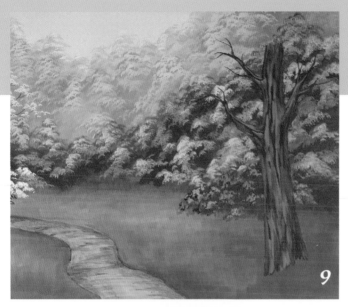

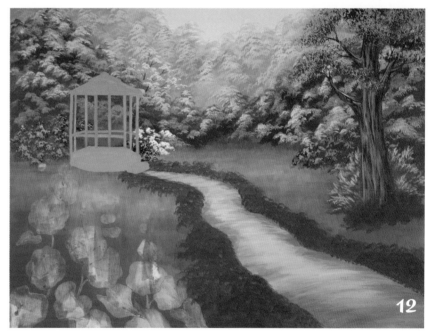

Step 9: Paint Foreground Tree Trunk

Paint the tree with Burnt Umber and the no. 6 round. Mix Burnt Umber + Titanium White (1:1) and paint streaks on the tree trunk with the no. 3 round. Add a little Burnt Umber shading. Paint horizontal Burnt Umber streaks on the path with the no. 6 round.

Step 10: Add Leaves to Tree

Highlight the tree trunk with Raw Sienna + Titanium White (1:1). Stamp foliage with Sap Green and a sea sponge. Brush mix several combinations of Raw Sienna + Titanium White and paint streaks on the path with the no. 8 filbert.

Step 11: Add Bushes Around Tree

Add lighter foliage to the tree with the sea sponge and Apple Orchard. With Sap Green + Apple Orchard (1:1), add a bush behind the tree with the no. 8 filbert. Paint a bush under the tree with Sap Green + Payne's Gray (1:1) and the no. 8 filbert.

Step 12: Stipple Foliage, Basecoat Gazebo

Stipple foliage on the bush behind the tree with Apple Orchard and Sap Green. Paint along the path with the Sap Green + Payne's Gray mixture from Step 11 and the no. 8 filbert.

Uncover the gazebo. Basecoat it with Burnt Umber + Titanium White (1:1) and the no. 6 round.

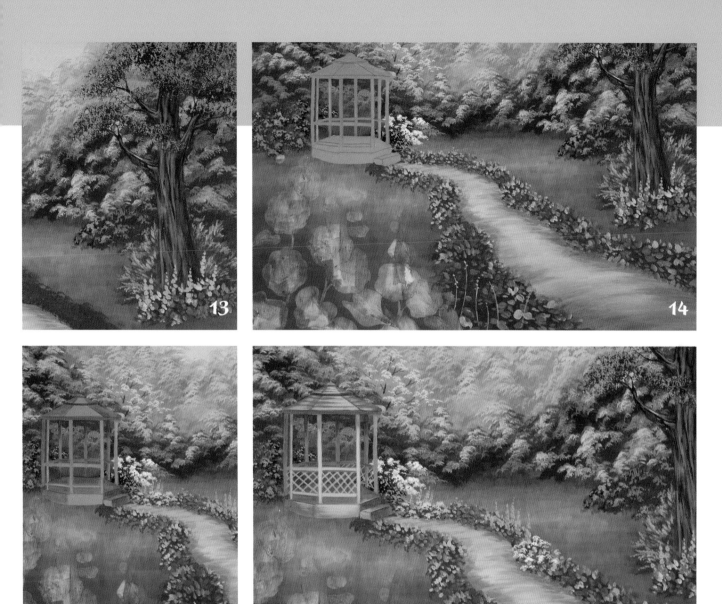

Step 13: Place Flowers Beneath Tree

Mix various greens of Sap Green + Titanium White and paint leaves in front of the tree with the no. 3 round. The lightest leaves are Apple Orchard + Titanium White (1:1). Add blue flowers with Cobalt Blue + Titanium White (1:1).

Step 14: Detail Flowers, Add Leaves to Border

Glaze a little Cobalt Blue on some flowers under the tree and dot Raw Sienna in the centers of the larger flowers. Along the path, add leaves following the technique in Step 13. Begin adding stems with Apple Orchard + Titanium White (1:1). Retransfer the gazebo details.

Step 15: Shade Gazebo, Add Blooms

Dilute Raw Umber to an inky consistency and shade the gazebo with the no. 6 round. Use the no. 4 filbert to stipple Sunny Yellow near the gazebo step, then dot Alizarin Crimson + Titanium White (1:touch). Add blue flower spikes with the Cobalt Blue mix.

Step 16: Detail Gazebo

Begin highlighting the gazebo with Titanium White + Burnt Umber (2:1) and the no. 3 round. Stipple Titanium White blossoms with the no. 8 filbert. Brush mix a touch more Burnt Umber into the gazebo highlight mix and add more details with the no. 3 round.

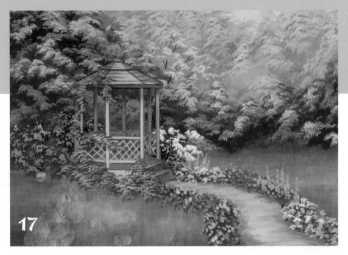

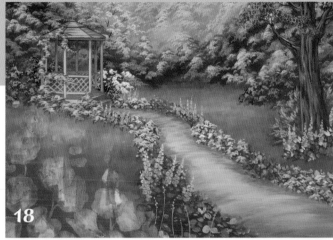

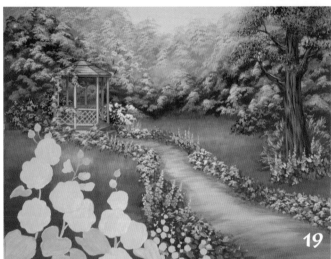

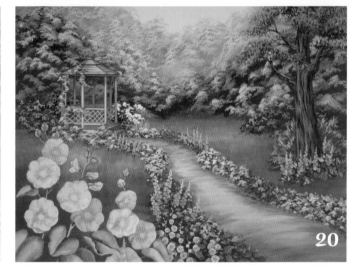

Step 17: Detail Gazebo

With a ruler and brown colored pencil, touch up the straight lines on the gazebo. Stipple foliage with Sap Green and the no. 4 filbert. Add lighter leaves with Apple Orchard. Mix Red Light + Titanium White (1:1) and stipple pink blossoms by the path.

Step 18: Add Blooms

Add more pink blossoms with the Red Light mixture. Brush mix more Titanium White into the mix for the lighter touches. Continue painting flowers along the path as before.

Step 19: Basecoat Hollyhocks

Remove the mask from the hollyhocks. An eraser can help remove any stubborn spots. Retransfer lines as necessary. Basecoat the flowers with Light Peony, using the no. 6 round. The leaves and stems are Apple Orchard + Coastal Blue (1:1). Continue adding flowers by the path.

Step 20: Shade Hollyhocks

Shade the hollyhock leaves with Sap Green and the no. 3 round. Paint the hollyhocks that are overlapped with a mixture of Light Peony + Red Light (1:touch). Shade with Butler Magenta + Alizarin Crimson (1:1).

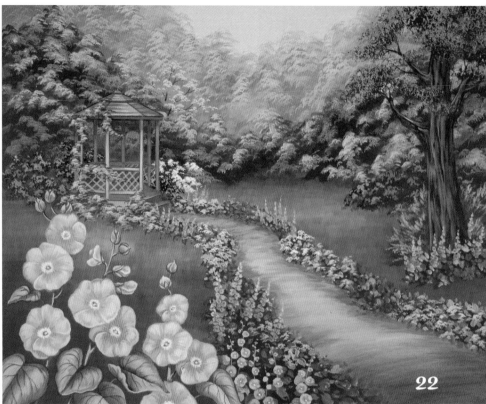

Step 21: Detail Hollyhocks

Paint the Hollyhock centers with Titanium White and the no. 3 round. Add leaf veins with Sap Green. Highlight the leaves with Soft Apple, using the no. 3 round. Glaze a little Apple Orchard over the highlights.

Step 22: Add Final Details

Paint some Sap Green + Titanium White (1:1) in the flower centers. Place a dot of Sunny Yellow in the middle. Detail with thin Raw Sienna. Highlight the flowers with Titanium White + Light Peony (2:1). Glaze thin Raw Sienna over portions of the gazebo and Burnt Umber over the end of the path, using the no. 3 round.

Autumn Aspen

I think autumn is my favorite season. I'm lucky enough to live in an area of the country where the trees put on a good fireworks show as soon as the weather begins to cool. This painting is of a lake near our house where we like to go camping. At this time of year, the wild sunflowers are usually covered with finches, stuffing themselves with seeds before winter arrives! If this painting seems too complex for you, try deleting the stepping stones and foreground flowers (Steps 18–24).

MATERIALS LIST

SURFACE
12" × 16" (30cm × 41cm) Canson Montval cold press watercolor paper

BRUSHES
¾-inch (19mm) wash; nos. 0, 3, 6 and 8 rounds; nos. 4 and 8 filberts; no. 8 flat shader

PLAID FOLKART ACRYLIC PAINT
Apple Orchard, Basil Green, Coastal Blue, Light Periwinkle, Lilac Love, Soft Apple, Sunny Yellow

PLAID FOLKART ARTIST'S PIGMENTS
Brilliant Ultramarine, Burnt Umber, Hauser Green Dark, Light Red Oxide, Payne's Gray, Sap Green, Titanium White, Yellow Light, Yellow Ochre

OTHER SUPPLIES
drafting tape (not masking tape), facial tissue, graphite transfer paper, masking fluid, sea sponge, sharp pencil or stylus

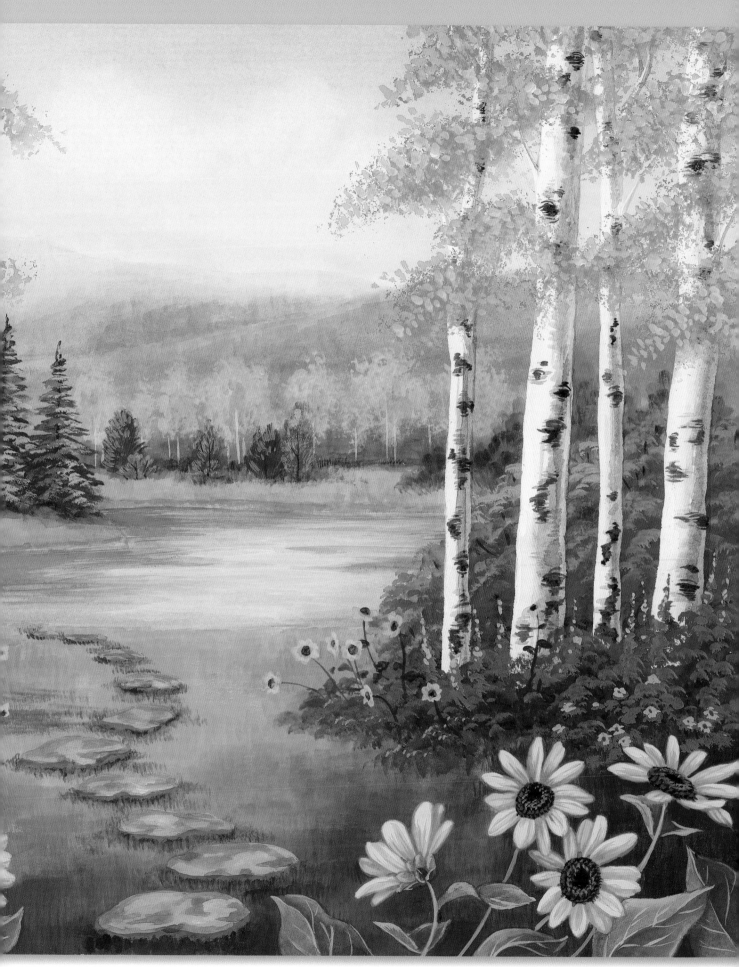

PATTERN

This pattern may be hand traced or photocopied for personal use only. Enlarge at 200% on a photocopier to bring it up to full size.

PREPARE FOR PAINTING

Tape off an 11" × 14" (28cm × 36cm) area on your watercolor paper. Transfer the pattern with graphite transfer paper and a sharp pencil or stylus (see page 10). Use the masking fluid to protect the trees and sunflowers (see page 11). Let the masking fluid dry thoroughly.

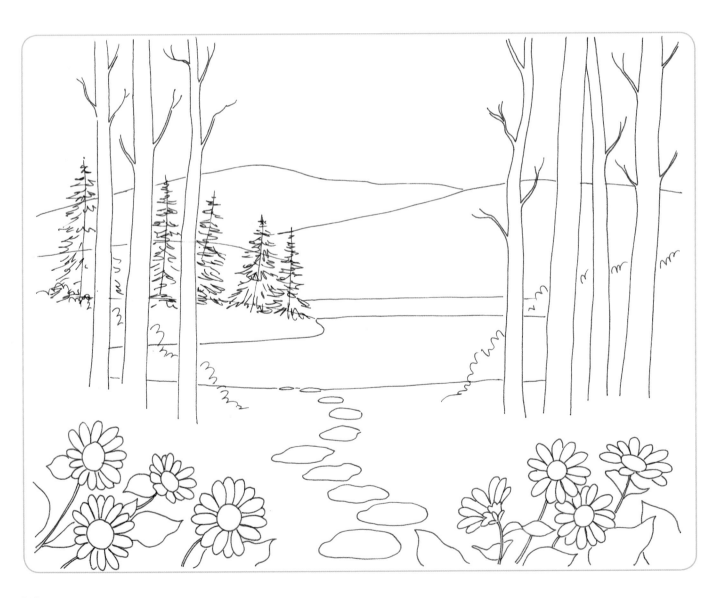

Color Mixes

Light Red Oxide + Yellow Ochre (1:1)

Sunny Yellow + Yellow Ochre (1:1)

Soft Apple + Apple Orchard (1:1)

Sap Green + Apple Orchard (1:1)

Sap Green + Soft Apple (1:1)

Light Periwinkle + Sap Green (2:1)

Coastal Blue + Payne's Gray (1:touch)

Brilliant Ultramarine + Light Periwinkle (1:1)

Coastal Blue + Lilac Love (1:1)

Lilac Love + Titanium White (1:1)

Yellow Ochre + Burnt Umber (2:1)

Burnt Umber + Payne's Gray (1:1)

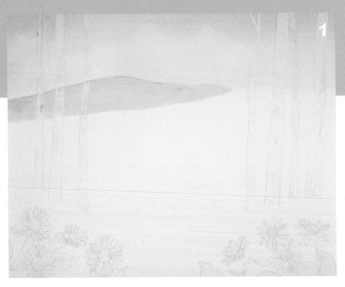

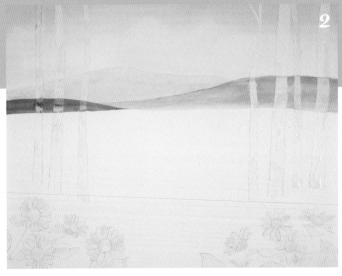

Step 1: Paint Sky, Distant Hill

Wet the sky with clean water and the ¾-inch (19mm) flat wash brush and paint a wash of diluted Coastal Blue. Blot out a few clouds with a wad of facial tissue (see page 14). Let dry, then paint a wash of Light Periwinkle across the top of the sky. Paint the most distant hill with Light Periwinkle.

Step 2: Paint Remaining Hills

Mix Light Periwinkle + Sap Green (2:1), dilute with water and paint another distant hill, using the no. 8 round. Add a touch of Payne's Gray and paint a third hill. Mix Titanium White + Light Periwinkle (1:touch) and soften the top of the most distant hill with short vertical strokes of the no. 8 flat shader.

Step 3: Shade Hills

Shade the most distant hill with Coastal Blue + Lilac Love (1:1) and the no. 8 flat shader. Add a touch of Sap Green to the mix for the darkest shading. Mix Lilac Love + Titanium White (1:1) and paint vertical strokes on the middle hill, letting the basecoat show through.

Step 4: Paint Middle Ground

Paint the ground with diluted Yellow Ochre and the ¾-inch (19mm) wash brush. Paint some Yellow Ochre on the hills with vertical strokes. With the no. 8 flat shader, mix Basil Green + Titanium White (1:generous touch) and add vertical strokes to the second and third hills; begin adding grass.

Step 5: Paint Distant Grass

Continue painting grass with Sunny Yellow + Yellow Ochre (1:1). Brush mix some Sap Green into this mixture for more grass. Paint along the edge of the lake with Yellow Ochre. Add a few strokes of Apple Orchard for the brightest greens.

Step 6: Paint Lake, Yellow Foliage

Mix Coastal Blue + Payne's Gray (1:touch), dilute to an inky consistency and paint the lake with horizontal strokes of the ¾-inch (19mm) wash brush.

Pat Sunny Yellow foliage behind the lake with a sea sponge. Shade underneath the foliage with Burnt Umber and the no. 8 flat shader.

Step 7: Detail Foliage, Add Pines

Add touches of diluted Sap Green and Yellow Light to the distant trees, and paint the trunks with Titanium White, using the no. 3 round. Stipple evergreen trees with Hauser Green Dark and the no. 8 flat shader.

Step 8: Add Reflections, Paint Foreground

Paint horizontal streaks on the lake with the no. 8 flat shader and Payne's Gray, Titanium White and Yellow Ochre. Paint the foreground with Soft Apple and the ¾-inch (19mm) wash brush. Add background shrubs with Light Red Oxide and Sap Green and the no. 4 filbert.

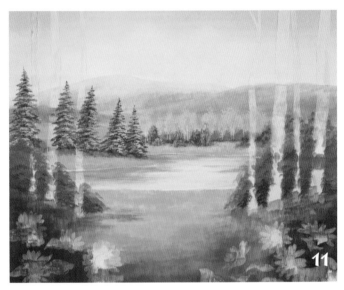

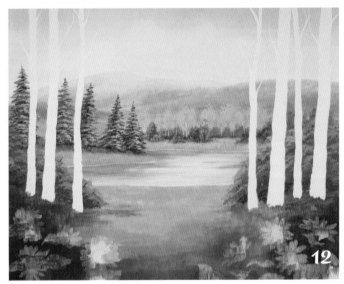

Step 9: Highlight Foliage, Pine Trees

Highlight the red shrubs with Light Red Oxide + Titanium White (1:1), and the green shrubs with Soft Apple. Add trunks with Burnt Umber and the no. 0 round.

Paint the evergreen trunks with Burnt Umber and the no. 3 round. Stipple middle-tone foliage with Sap Green + Soft Apple (1:1) and highlights with Soft Apple, using the no. 8 filbert.

Step 10: Paint Foreground Grass

Shade under the evergreens with Burnt Umber and the no. 8 flat shader. Begin painting the foreground grass with short vertical strokes of the ¾-inch (19mm) wash brush and Sunny Yellow + Yellow Ochre (1:1), Apple Orchard, Sap Green + Apple Orchard (1:1) and Sap Green.

Step 11: Paint Foreground Bushes

Paint bushes behind the aspen trees with Sap Green and with Light Red Oxide + Yellow Ochre (1:1), using the no. 8 filbert. Shade with Sap Green and Burnt Umber. Paint more grass with Sap Green, Hauser Green Dark and Burnt Umber, using the ¾-inch (19mm) wash brush.

Step 12: Detail Bushes, Unmask Aspens

Brush mix Titanium White into the red bush mix and paint highlights on the bush. Add a few twigs with Burnt Umber and the no. 3 round. Remove the mask from the trees. Paint branches with Titanium White and the no. 3 round.

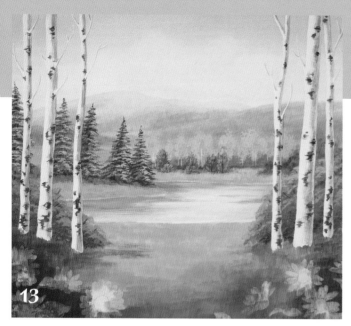

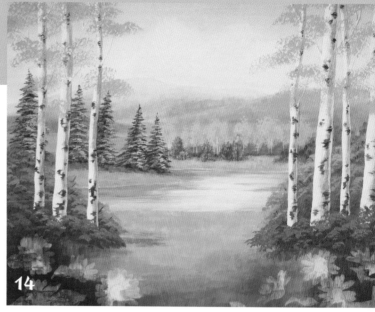

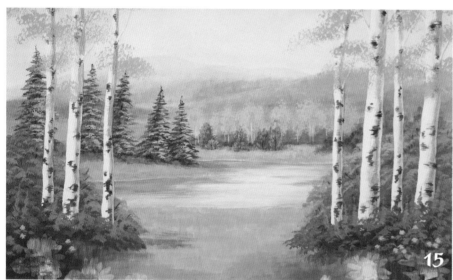

Step 13: Detail Aspens

Mix Burnt Umber + Payne's Gray (1:1), dilute until very thin and transparent and shade the aspens with the no. 3 round. Use the mix undiluted to paint the dark spots. Add more details with diluted Yellow Ochre + Burnt Umber (2:1), still using the no. 3 round. (See page 20 for more instruction on painting tree bark.)

Step 14: Add Foliage Around Aspens

Paint foliage in front of the trees with Sap Green and Sap Green + Titanium White (1:generous touch) and the no. 8 filbert. With the sea sponge pat a mix of Soft Apple + Apple Orchard (1:1) onto the aspens.

Step 15: Add Foreground Flowers

Pat some purple blossoms with the no. 4 filbert and Lilac Love. Add a few lighter flowers with Lilac Love + Titanium White (1:1). Mix Brilliant Ultramarine + Light Periwinkle (1:1) and stipple the blue flower spikes.

Step 16: Highlight Aspen Leaves, Flowers

Pat some Yellow Ochre foliage onto the aspens with the sea sponge. Highlight the blue flowers with Titanium White + Brilliant Ultramarine (2:1), and dot centers into the purple flowers with Brilliant Ultramarine + Lilac Love (1:1), using the no. 3 round.

TIP

When shading the aspen trunks, notice that the darkest part of the shadow doesn't go all the way to the edge. Leaving a lighter edge gives the illusion of reflected light and helps the trunks look round.

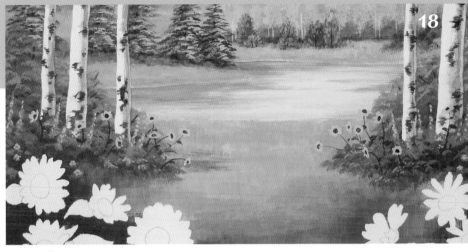

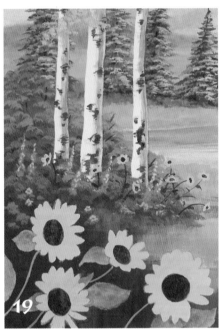

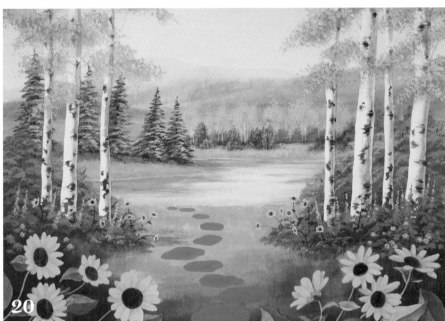

Step 17: Paint Distant Sunflowers

Paint stems and leaves for the sunflowers with Hauser Green Dark and the no. 0 round. Add yellow leaves to the aspens with Yellow Light + Titanium White (2:1) and the no. 3 round. Use the same mix to paint distant sunflowers under the trees.

Step 18: Detail Distant Sunflowers

Add Burnt Umber centers to the distant sunflowers with the no. 3 round. Stipple more Lilac Love blossoms in the foreground as desired with the no. 4 filbert. Remove the masking fluid from the foreground flowers and retransfer any lines as necessary.

Step 19: Basecoat the Near Sunflowers

Paint the leaves of the near sunflowers with diluted Sap Green and the no. 6 round. Paint the petals with Yellow Light + Titanium White (1: touch), and the flower centers with Burnt Umber. The stems are Soft Apple + Apple Orchard (1:1), painted with the no. 3 round.

Step 20: Base Stepping Stones, Shade Flowers

Transfer the stepping stones and basecoat with Burnt Umber + Payne's Gray + Titanium White (1:1:1) and the no. 6 round.

Shade one half of each near sunflower leaf with diluted Sap Green, and shade the sunflower petals with Yellow Ochre.

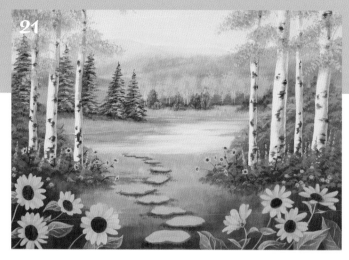

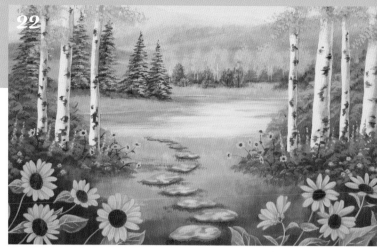

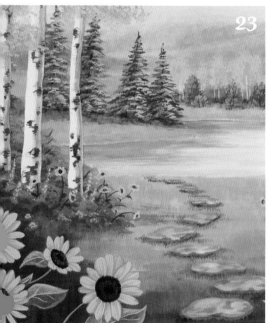

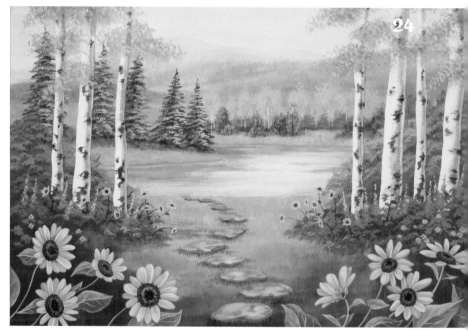

Step 21: Detail Stones, Sunflowers

Add more Titanium White to the stone mixture from Step 20 and paint the tops of the stepping stones. Paint grass around the stones with Sap Green and the no. 4 filbert.

Highlight the sunflower leaves and draw the leaf veins with Soft Apple and the no. 3 round.

Step 22: Highlight Stones, Detail Sunflowers

With the no. 3 round, add texture to the stones with Burnt Umber + Payne's Gray (1:1), diluted until very thin and watery. Highlight the foreground stones with diluted Titanium White. Add details to the flower petals with thin Yellow Ochre + Burnt Umber (1:1) and the no. 0 round.

Step 23: Glaze Stones

Glaze a thin wash of Yellow Ochre across some areas of the stones with the no. 3 round. Soften the grass around the stones with Sunny Yellow + Yellow Ochre (1:1), painted with the no. 4 filbert. Use an undiluted mix of Burnt Umber + Payne's Gray (1:1) to stipple shading on the flower centers with the no. 4 filbert.

Step 24: Detail Sunflowers

Stipple texture to the flower centers with Burnt Umber + Titanium White (2:1) and Sunny Yellow + Yellow Ochre (1:1). Highlight the petals with Titanium White + Yellow Light (1:touch), using the no. 3 round. Glaze the leaves with Yellow Light. Add shading to the far lake shore with very thin Burnt Umber.

The Old Stone Bridge

THIS BRIDGE ACTUALLY SPANS THE ROAD IN
ACADIA NATIONAL PARK, BUT I EXERCISED MY
ARTISTIC LICENSE AND TURNED THE ROAD INTO
A SMALL RIVER. WHEN DESIGNING YOUR OWN
COMPOSITIONS, NEVER FEEL LIKE YOU NEED TO
FOLLOW A PHOTOGRAPH OF A SCENE TOO CLOSELY.
USING YOUR IMAGINATION IS ONE OF THE BEST
PARTS OF BEING AN ARTIST!

MATERIALS LIST

SURFACE
12" × 16" (30cm × 41cm) Canson Montval cold press watercolor paper

BRUSHES
¾-inch (19mm) wash; nos. 0 and 5 rounds; no. 8 flat; ¾-inch (19mm)
mop; nos. 4 and 8 filberts

PLAID FOLKART ACRYLIC PAINT
Apple Orchard, Baby Blue, Baby Pink, Dove Gray, Fresh Foliage,
Heather, Lemonade, Mint Green, Slate Blue, Turquoise

PLAID FOLKART ARTIST'S PIGMENTS
Burnt Umber, Cobalt Blue, Red Light, Sap Green, Titanium White,
Van Dyke Brown, Yellow Light, Yellow Ochre

OTHER SUPPLIES
drafting tape (not masking tape), graphite transfer paper, masking fluid,
sharp pencil or stylus, white transfer paper

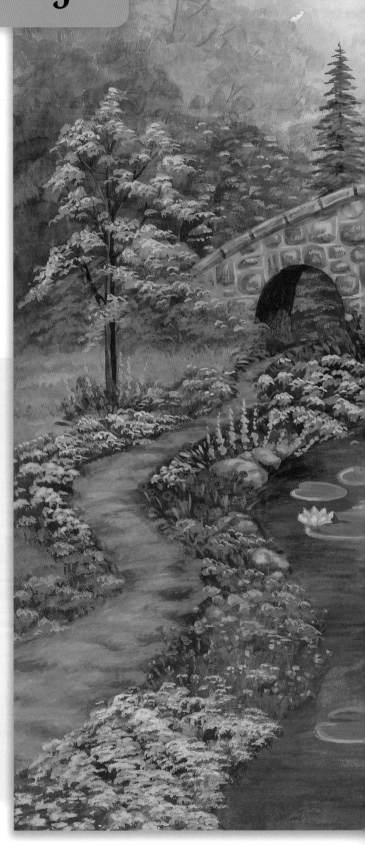

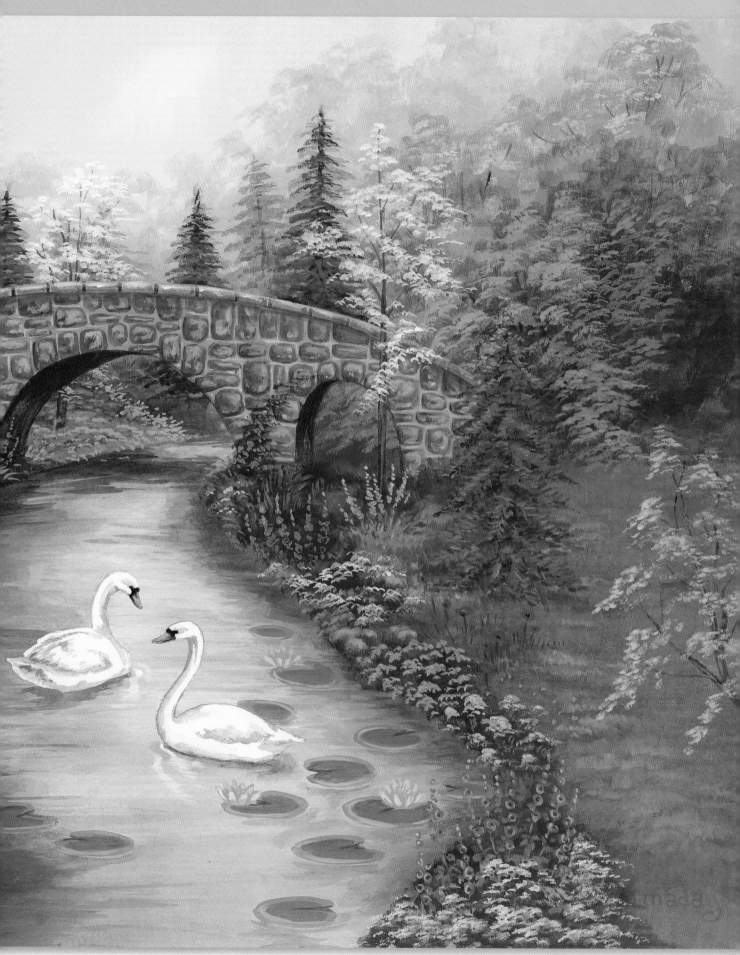

PATTERN

This pattern may be hand traced or photocopied for personal use only. Enlarge at 200% on a photocopier to bring it up to full size.

PREPARE FOR PAINTING

Tape off an 11" × 14" (28cm × 36cm) image area with drafting tape. Trace and transfer the swans, river, path, and bridge using graphite transfer paper and a sharp pencil or stylus (see page 10). You'll transfer the trees later. Use masking fluid to cover the bridge and swans (see page 11).

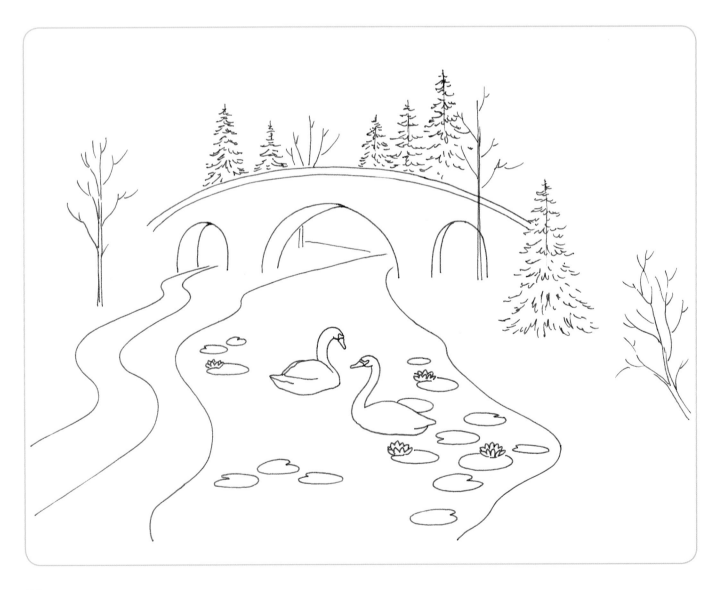

COLOR MIXES

Baby Pink + Red Light (1:1)

Red Light + Lemonade (1:1)

Yellow Light + Red Light (2:1)

Lemonade + Sap Green + Yellow Light (1:1:touch)

Yellow Ochre + Sap Green + Titanium White (2:1: touch)

Turquoise + Sap Green (2:1)

Sap Green + Baby Blue (2:1)

Sap Green + Slate Blue (1:1)

Sap Green + Payne's Gray (1:1)

Sap Green + Burnt Umber (2:1)

Mint Green + Baby Blue + Sap Green (1:1:1)

Mint Green + Baby Blue (1:1)

Baby Blue + Titanium White (2:1)

Heather + Titanium White (1:1)

Burnt Umber + Yellow Ochre (1:1)

Burnt Umber + Lemonade (1:1)

Dove Gray + Van Dyke Brown (1:1)

1

2

3

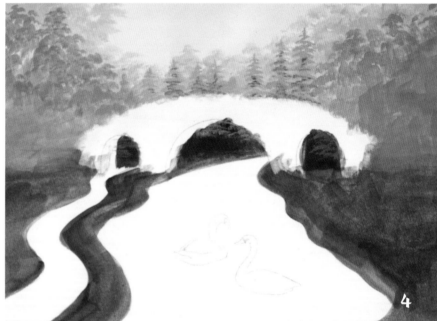

4

Step 1: Paint Sky

Wet the sky area with clean water and the ¾-inch (19mm) wash. Starting in the center of the paper, paint a patch of Lemonade, using the ¾-inch (19mm) wash. Working quickly, before the paper dries, add Baby Pink around the yellow, then Baby Blue at the sides. Blend the colors with a clean, dry ¾-inch (19mm) mop brush. Add a little Titanium White to the center of the yellow area. Let dry.

Step 2: Place Lightest Distant Trees

Mix Heather + Titanium White (1:1) and begin to pat in color for the distant trees with the no. 8 filbert. Use short, vertical strokes and leave plenty of sky showing through. This is only a suggestion of very distant trees. Add a little more Titanium White to the mix and paint some lighter foliage along the edges.

Step 3: Add Darker Distant Foliage

Clean the no. 8 filbert and mix Mint Green + Baby Blue (1:1). Paint more foliage beneath the purple treetops from Step 2. Switch to the ¾-inch (19mm) wash for the larger areas. Mix Sap Green + Slate Blue (1:1) and paint the dark foliage under the bridge.

Mix Sap Green + Mint Green + Baby Blue (1:1:1) and stipple in a few distant evergreen trees, still using the no. 8 filbert.

Step 4: Basecoat Ground

Dilute the Sap Green/Slate Blue mixture with water to a milky consistency and paint the ground with the ¾-inch (19mm) wash. Blend this color into the distant trees by adding some Mint Green to the mixture. Mix Sap Green + Baby Blue (2:1) and, with the no. 8 filbert, add leafy, green background trees that extend from the purple treetops to the ground.

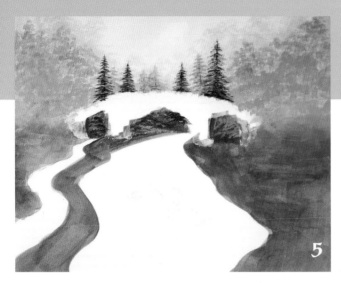

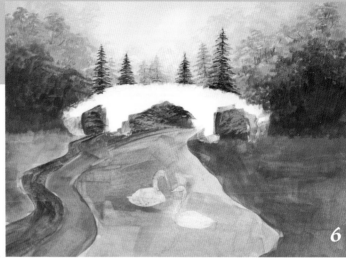

Step 5: Paint Dark Evergreens

Dilute Burnt Umber to an inky consistency and draw the trunks of the dark evergreens with the no. 5 round. With the edge of the no. 8 filbert, stipple in the branches with Sap Green. For the highlights, use Sap Green + Yellow Light + Titanium White (1:1:touch). For the darkest areas, use Sap Green + Burnt Umber (2:1).

Step 6: Basecoat Path, Water; Add Distant Flowers

With the ¾-inch (19mm) wash brush, paint the water with Slate Blue diluted to a watery consistency. Paint the path with diluted Burnt Umber and the no. 5 round.

Stipple a little Heather under the bridge with the no. 8 filbert. Draw in a few twigs with the no. 5 round and diluted Burnt Umber.

With the no. 8 filbert, mix Lemonade + Sap Green + Yellow Light (1:1:touch) and stipple in a little light foliage over the dark distant foliage from Step 3. Clean the no. 8 filbert, load it with Lemonade and stipple a highlight on the foliage.

Mix Yellow Ochre + Sap Green + Titanium White (2:1:touch) and paint foliage on the left side. Add twigs with the no. 5 round and diluted Burnt Umber. Add a dark shadow green to the bottom of the foliage with Sap Green + Burnt Umber (2:1), using the no. 8 filbert.

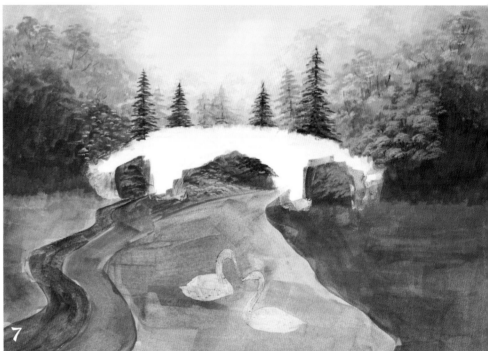

Step 7: Add Flowers Under Bridge

Mix Red Light + Lemonade (1:1) and stipple the pink flowers on the right-side bush and beneath the bridge with the no. 8 filbert. Add more Lemonade for lighter flowers on top. Paint twigs as you did in Step 6.

Dot in the purple flowers on the left-side bush with Heather, still using the no. 8 filbert. Add a little Titanium White for the lighter flowers, and use the Lemonade + Sap Green + Yellow Light mixture from Step 6 for the lighter leaves.

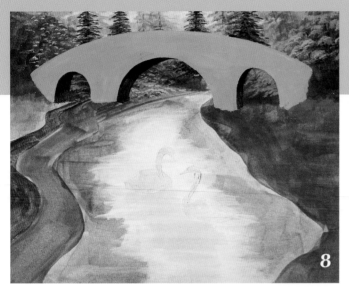

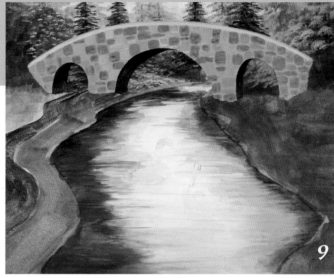

Step 8: Basecoat Bridge

Remove the masking fluid from the bridge. Retransfer any lines as needed. Paint the underside of the bridge with Van Dyke Brown and the no. 5 round. The rest of the bridge is Dove Gray + Van Dyke Brown (1:1), painted with a no. 8 flat.

Mix Baby Blue + Titanium White (2:1) and paint the middle of the water with the no. 8 flat.

Step 9: Paint Stones, Water

Paint the stones on the bridge with the no. 8 flat and mixes of Burnt Umber + Titanium White (2:1) and Payne's Gray + Titanium White + Burnt Umber (1:1:touch). Paint the top of the bridge with Titanium White + Burnt Umber (2:1).

Mix Sap Green + Payne's Gray (1:1), dilute to an inky texture and paint the dark areas of water (along the left and right banks and under the bridge) with horizontal strokes of the no. 8 flat. Blend the edges of this dark color with the Baby Blue.

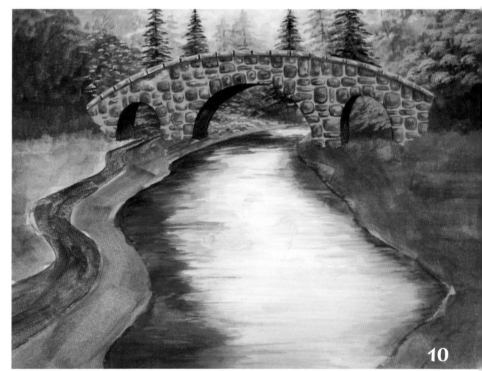

Step 10: Shade Stones, Highlight Water

Dilute Van Dyke Brown until it is very thin and transparent, then shade the stones with the no. 5 round (or a smaller round brush, if you prefer). Glaze Van Dyke Brown under the bridge as well.

Dilute a mix of Lemonade + Titanium White (2:1) to a creamy consistency and add it to the center of the water with the no. 5 round. Blend pure Titanium White along the left side of the areas you painted with the Lemonade/Titanium White mixture.

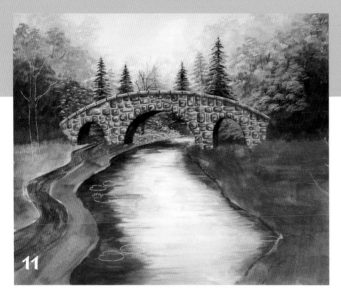

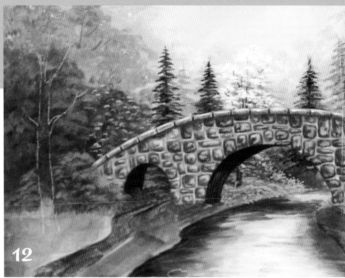

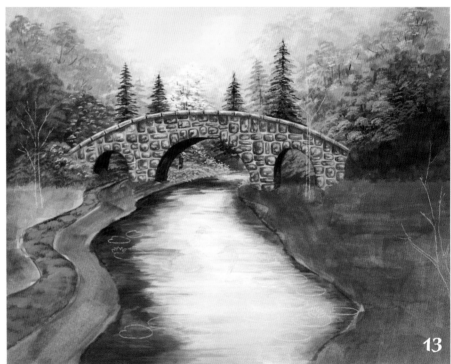

Step 11: Transfer Foreground Trees, Lily Pads

With the white transfer paper, transfer the tree trunks and lily pads. Mix Titanium White + Lemonade (1:touch) and highlight the bridge stones with the no. 5 round.

Paint the tree behind the bridge with Van Dyke Brown and the no. 0 round. Mix Yellow Light + Titanium White (2:1) and dot yellow flowers on the ground behind the bridge, still using the no. 0 round.

Step 12: Add White Tree Blossoms, Left-Side Shrub

Mix Titanium White + Baby Blue (1:1) and, with the no. 4 filbert, tap a few blossoms on the tree you painted in Step 11. Add pure Titanium White blossoms over the top.

Add a small shrub on the left side of the bridge by stippling on Sap Green with a no. 8 filbert. Stipple the shrub's lighter foliage with Fresh Foliage.

Step 13: Add Blooms; Detail Bush, Path

Stipple purple flowers on the left-side shrub with Heather and the no. 4 filbert. Mix Heather + Titanium White (1:1) for the lighter flowers at the top of the bush.

Add Fresh Foliage to the top of the bush at the upper right of the painting with the no. 8 filbert.

Mix Burnt Umber + Lemonade (1:1) and begin developing the path with the no. 4 filbert and loose, horizontal strokes.

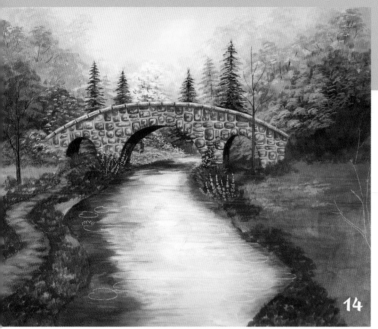

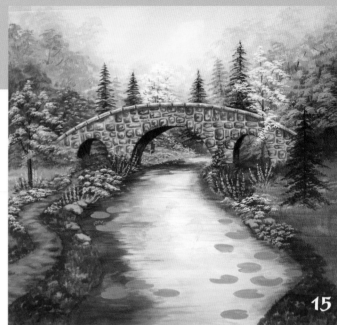

Step 14: Place Foreground Elements

Glaze thin Heather on the river with the no. 5 round. Highlight the path with Yellow Ochre + Titanium White (2:1). Let dry, then glaze Burnt Umber + Yellow Ochre (1:1) over the top.

Lay in foliage along the river with Sap Green + Payne's Gray (1:1) and the no. 8 filbert. Paint the foreground tree trunks with Burnt Umber and the no. 5 round.

Begin adding grass with short strokes of the no. 8 filbert and Apple Orchard. Add a touch of Titanium White for the lightest grass. Paint the blue flowers near the bridge with Cobalt Blue + Titanium White (1:1) and the no. 0 round. The darker flowers are pure Cobalt Blue. Add leaves with Apple Orchard.

Highlight the tree trunks with Burnt Umber + Lemonade (1:1).

Step 15: Add Blooms, Detail Foreground

Stipple in pink flowers on the trees and ground with Baby Pink + Red Light (1:1) and the no. 4 filbert. Highlight with Baby Pink + Titanium White (1:1). Paint the white blossoms on the tree and ground as you did in Step 12.

Lay in the rocks on the riverside with Dove Gray + Van Dyke Brown (1:1), still using the no. 4 filbert. Let dry. Shade the rocks with Van Dyke Brown + Payne's Gray (1:1) and the no. 4 filbert. Paint the lily pads with Fresh Foliage and the no. 5 round.

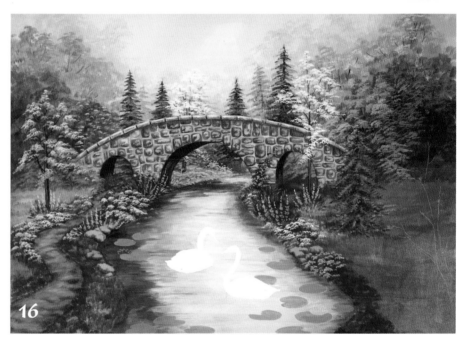

Dot in yellow flowers with the no. 0 round and Yellow Ochre + Titanium White (1:1). Add darks with pure Yellow Ochre and highlight with Yellow Light + Titanium White (1:1). Draw the foreground evergreen trunk with Burnt Umber and the no. 5 round. Stipple foliage on the trunk with the no. 8 filbert and Sap Green + Payne's Gray (1:1).

Step 16: Develop Foreground Bushes, Trees

Continue developing the bush on the right side as you did in Step 7. Stipple the foreground evergreen foliage with the no. 8 filbert and Turquoise + Sap Green (2:1). Add a touch of Mint Green for highlights. Add a little of these blue-green mixes to the background evergreens as well. Remove the mask from the swans.

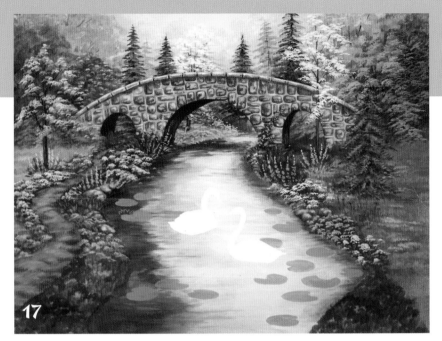

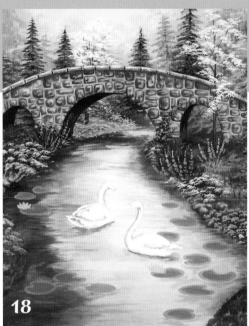

Step 17: Finish Rocks on Banks, Add Colorful Blooms

Finish the rocks using the same techniques you used for the bridge stones in Steps 10 and 11.

Paint the red flowers with Red Light + Lemonade (1:slight touch) and the no. 5 round. The stems are Fresh Foliage and Sap Green. The centers are Burnt Umber.

Continue painting the grass as before. Add more purple flowers with Heather as you did in Step 7, and add more pink flowers as you did in Step 15.

Step 18: Shade Swans, Paint Water Lilies

Dilute the Van Dyke Brown + Payne's Gray mixture until it is very thin and transparent, and use it to shade the swans with the no. 5 round. Shade under the swans as well.

Paint the water lilies with Baby Pink, still using the no. 5 round. Mix Apple Orchard + Sap Green (1:touch) and paint the centers of the lily pads. Dilute the mixture with water and glaze a little green on the water around the lily pads as reflections.

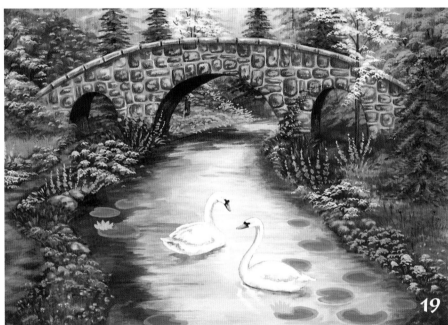

Step 19: Detail the Swans

Mix Yellow Light + Red Light (2:1) and paint the swans' beaks with the no. 0 round. Add dark details with Payne's Gray. Add a few Titanium White reflections on the water.

Dot in more blue flowers with Cobalt Blue + Titanium White (1:touch). Add more Titanium White to the mix for highlights. Use the Turquoise/Sap Green mix from Step 16 for stems.

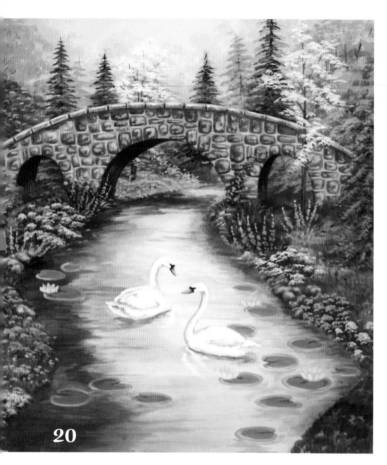

20

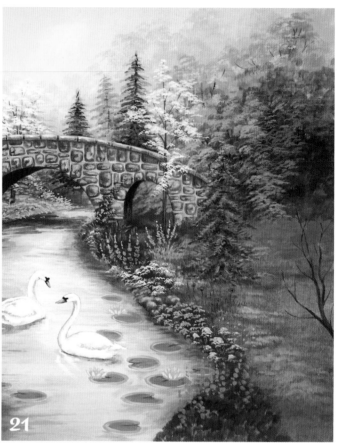

21

Step 20: Detail Lily Pads

Highlight the lily pads with Titanium White + Apple Orchard (2:1) and detail the closest pads with a little Sap Green, still using the no. 0 round. The distant pads should have less detail. Mix Titanium White + Baby Pink (2:1) and paint the lily petals. Stipple more flowers along the riverbank as before.

Step 21: Detail Water Lilies

With the no. 0 round, add yellow centers to the water lilies with Yellow Light + Yellow Ochre (1:generous touch). Detail with Baby Pink + Red Light (1:1).

Paint the tree branch in the lower right corner with Burnt Umber and the no. 5 round.

Paint some flower spikes in the foreground with Cobalt Blue + Titanium White (1:touch) and others with Heather. Continue adding grass as before.

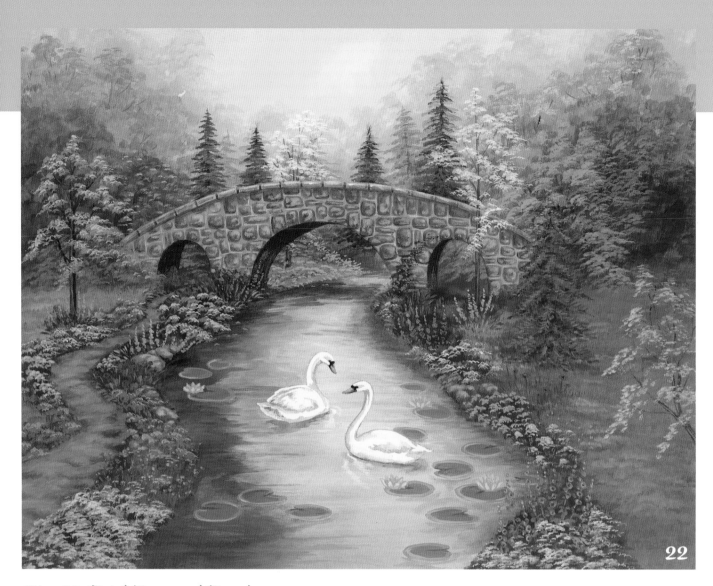

22

Step 22: Detail Foreground Branch

Highlight the branches with Burnt Umber + Titanium White (1:1), then stipple on Heather blooms with the no. 8 filbert. Highlight with Heather + Titanium White (1:1).

Highlight the flower spikes by adding Titanium White to their base colors, then dot in the centers with Cobalt Blue + Heather (1:1), using the no. 0 round. The stems and leaves are Apple Orchard. Paint the remaining white flowers as you did in Step 12.

Seaside Sentinel

LIGHTHOUSES ARE A VERY POPULAR SUBJECT FOR PAINTINGS. THEY ARE ATTRACTIVE BUILDINGS IN LOVELY LANDSCAPE SETTINGS, BUT I THINK WE ARE ALSO ATTRACTED BY THE SYMBOLISM OF BEING GUIDED HOME TO SAFETY. THE LIGHTHOUSE IN THIS PAINTING IS A COMPOSITE OF SEVERAL DIFFERENT BUILDINGS. MANY LIGHTHOUSES ARE NOW PRIVATELY OWNED, AND IF YOU WANT TO PAINT ONE AND SELL THE IMAGE FOR PROFIT, YOU WOULD NEED TO GET PERMISSION FROM THE OWNER.

MATERIALS LIST

SURFACE
12" × 16" (30cm × 41cm) Canson Montval cold press watercolor paper

BRUSHES
1-inch (25mm) wash; nos. 3, 6, and 10 rounds; no. 8 filbert; no. 8 flat

PLAID FOLKART ACRYLIC PAINT
Apple Orchard, Coastal Blue, Green Forest, Light Peony, Sunny Yellow

PLAID FOLKART ARTIST'S PIGMENTS
Burnt Umber, Cobalt Blue, Hauser Green Dark, Light Red Oxide, Payne's Gray, Raw Sienna, Raw Umber, Red Light, Sap Green, Titanium White, Yellow Light

OTHER SUPPLIES
drafting tape (not masking tape), facial tissue, graphite transfer paper, masking fluid, sea sponge, sharp pencil or stylus

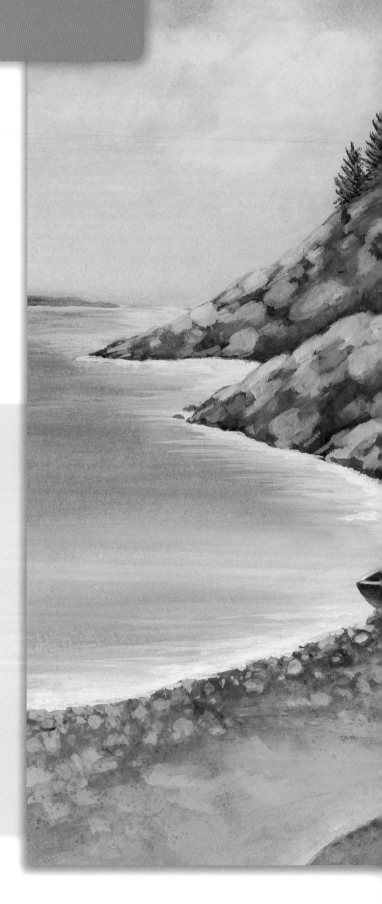

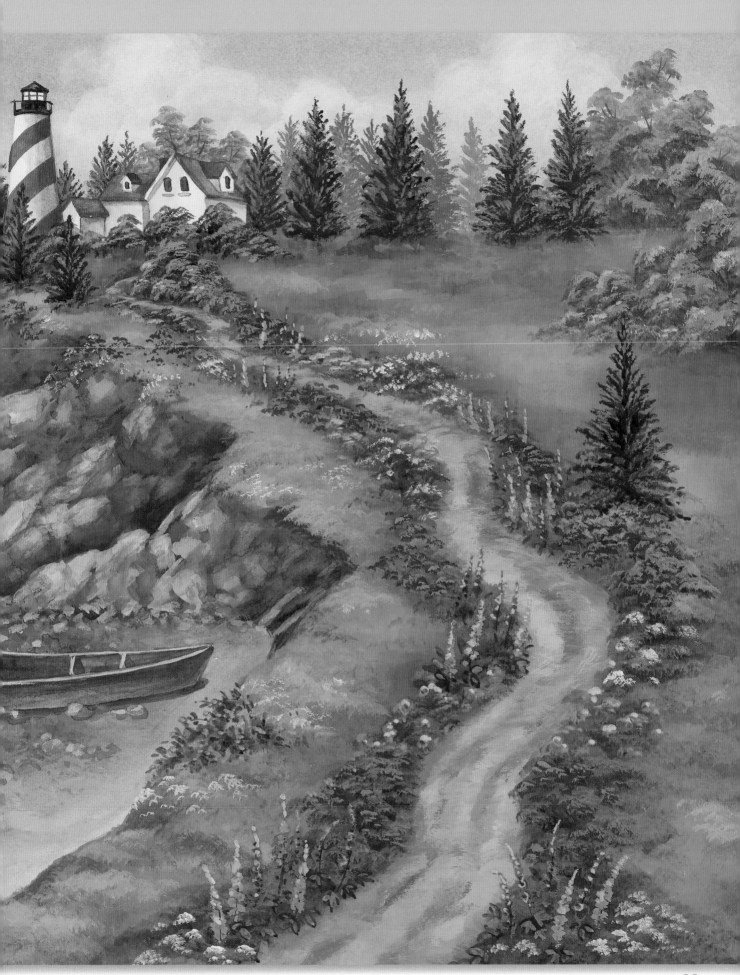

PATTERN

This pattern may be hand traced or photocopied for personal use only. Enlarge at 200% on a photocopier to bring it up to full size.

PREPARE FOR PAINTING

Use the drafting tape to mask the edges of an 11" × 14" (28cm × 36cm) area on your paper. Transfer the pattern, except for the trees, using graphite transfer paper and a sharp pencil or stylus (see page 10). With the masking fluid, protect the lighthouse, cottage and boat (see page 11). Let dry.

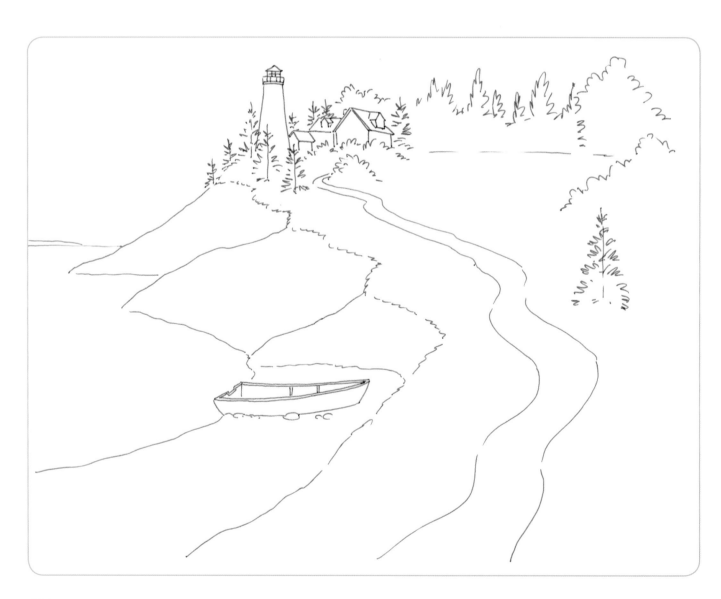

COLOR MIXES

Red Light + Sunny Yellow + Titanium White (1:1:touch)

Yellow Light + Raw Sienna (1:generous touch)

Sunny Yellow + Hauser Green Dark (3:1)

Apple Orchard + Titanium White (1:1)

Apple Orchard + Sap Green (1:1)

Sap Green + Titanium White (1:1)

Green Forest + Hauser Green Dark (1:1)

Green Forest + Raw Umber (2:1)

Green Forest + Cobalt Blue (2:1)

Coastal Blue + Cobalt Blue (2:1)

Light Peony + Cobalt Blue (1:1)

Light Peony + Cobalt Blue (2:1)

Raw Sienna + Raw Umber (1:1)

Step 1: Block in Sky, Grass

Wet the sky with the 1-inch (25mm) wash brush, then paint a wash of diluted Coastal Blue + Cobalt Blue (2:1), letting the color fade away as it approaches the horizon. Blot out clouds with a crumpled facial tissue (see page 14). Touch up with Titanium White if necessary. Paint the grass with diluted Sap Green.

Step 2: Basecoat Water, Cliffs, Path

Brush mix a little Payne's Gray into the sky mix and paint the sea with the no. 8 flat. Add streaks of Titanium White near the shore while the paint is still wet. Basecoat the cliffs with diluted Raw Umber, using the no. 10 round. The path and beach are Raw Sienna + Raw Umber (1:1), diluted to an inky consistency.

Step 3: Add Pink Washes, Glaze Shoreline

Paint a very thin wash of Light Peony at the bottom of the sky, and add washes of this color to the undersides of the clouds, using the no. 6 round. Touch up the cloud edges with Titanium White. Glaze Raw Umber along the shoreline.

Step 4: Texture Coastline, Add Trees

Stamp texture on the beach and cliffs with a dry sea sponge and thin Raw Umber. Begin defining the rocks on the cliffs with Raw Umber (undiluted) and the no. 6 round.

Begin adding trees with the edge of the no. 8 filbert. Use Green Forest + Hauser Green Dark (1:1) for the evergreens and Sap Green for the other trees.

TIP

When painting a sky wash that you want to be darker at the top, sometimes it helps to turn the painting upside down as the color naturally will flow towards the bottom of the paper.

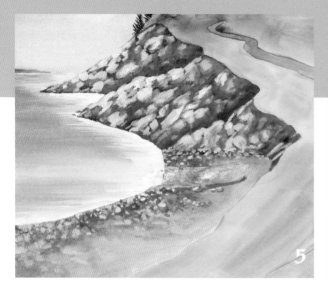

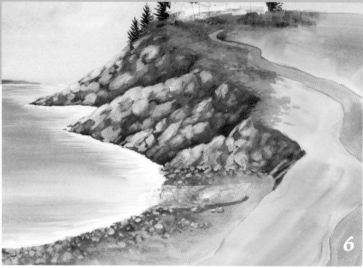

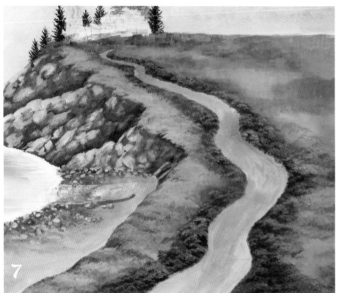

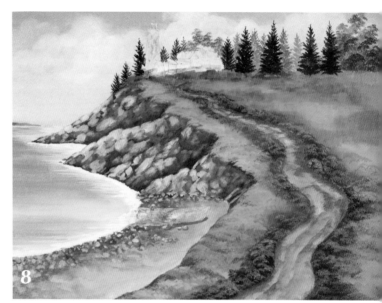

Step 5: Paint Rocks

Brush mix various combinations of Raw Umber + Raw Sienna + Titanium White and paint the rocks on the cliff and beach with the no. 8 flat. Use the no. 6 round for smaller rocks. Add more Raw Umber to the mix to shade them. Shade under the boat with pure Raw Umber.

Step 6: Glaze Rocks, Add Grass

Finish the rocks with lots of thin glazes of Payne's Gray, Raw Sienna, Burnt Sienna and Sap Green, using the no. 10 round. Stipple Titanium White at the waterline with the no. 8 flat to simulate splash and foam. Begin to paint grass with short vertical strokes of the no. 8 flat and Sap Green + Titanium White (1:1) and Apple Orchard, starting in the upper left corner of the grass.

Step 7: Detail Grass

Continue painting grass as before. Add more grass with Apple Orchard + Titanium White (1:1) and Apple Orchard + Sap Green (1:1) Switch to the no. 8 filbert to add more texture to the foreground grass. Concentrate the darkest greens along the path.

Step 8: Add More Trees, Shade Path

Paint more background trees as you did in Step 4. Add Titanium White to the evergreen mix for the most distant trees. Still using the no. 8 filbert, shade the path with Raw Sienna + Raw Umber (1:1) diluted to the texture of cream.

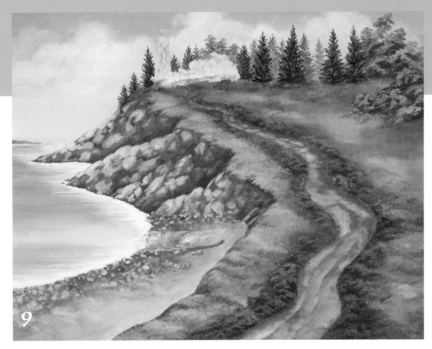

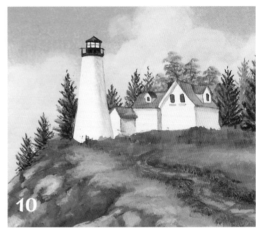

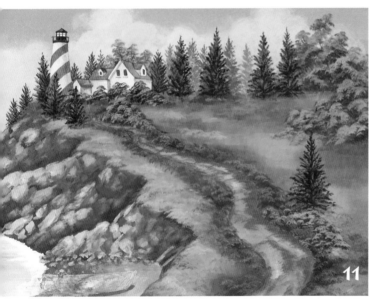

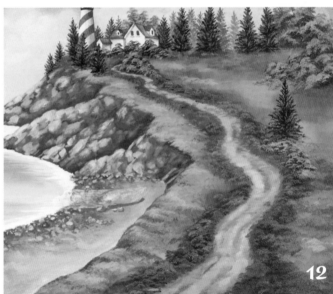

Step 9: Highlight Grass, Foliage

Add touches of Sunny Yellow to the grass with the no. 8 filbert. Highlight the evergreens with Sunny Yellow + Hauser Green Dark (3:1). Highlight the other foliage with Apple Orchard + Titanium White (1:1). Add another bush on the right. Paint trunks and branches with Raw Umber and the no. 3 round.

Step 10: Shade Lighthouse, Paint Roofs

Uncover the lighthouse and cottage. Retransfer the details. With the no. 3 round, shade the buildings with very diluted Payne's Gray + Raw Umber (1:touch). Paint the top of the lighthouse and the windows with pure Payne's Gray, and paint the roofs with Light Red Oxide.

Step 11: Detail Lighthouse, Add Blooms

Paint the stripes on the lighthouse with thin Red Light and the no. 3 round. Paint thin glazes of Raw Sienna on the front of the buildings. Add more evergreens and bushes as before. Stipple blossoms with Light Peony + Cobalt Blue (2:1) and the no. 8 filbert.

Step 12: Detail the Path

Brush mix various combinations of Raw Sienna and Titanium White and highlight the path with the no. 8 filbert. Extend the foliage alongside to overlap the sides of the path. Shade the roofs with thin Raw Umber and the no. 3 round.

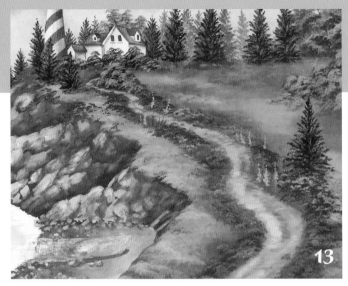

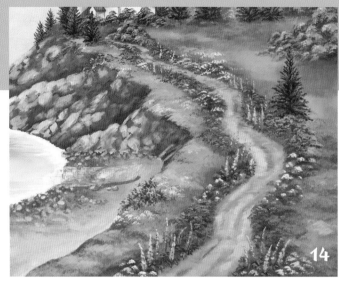

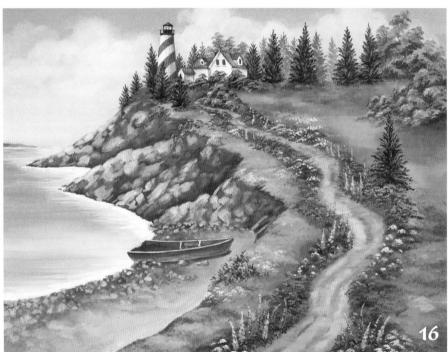

Step 13: Add Blooms to Path

With the no. 8 filbert, stipple red blossoms along the path with Red Light. The yellow flowers are Yellow Light + Raw Sienna (1:generous touch). Switch to the no. 3 round and dot in blue flowers with Cobalt Blue + Titanium White (1:1) and Light Peony + Cobalt Blue (2:1).

Step 14: Detail the Flowers

Continue painting flowers as before, adding Titanium White blossoms. Add leaves with Sap Green and Apple Orchard and the no. 3 round. Highlight the red flowers with Red Light + Sunny Yellow + Titanium White (1:1:touch). Highlight the blue, purple and yellow flowers by brush mixing Titanium White with their base colors.

Step 15: Paint the Boat

Remove the mask from the boat. Retransfer the details. Paint the outside of the boat with diluted Green Forest + Cobalt Blue (2:1) and the no. 3 round. The interior of the boat is Green Forest + Raw Umber (2:1). Leave the white edge as plain paper, or paint it in with Titanium White.

Step 16: Add Final Details

Shade the boat with glazes of Raw Umber and the no. 3 round. Paint a thin glaze of the Green Forest/Raw Umber mixture on the white edges. Add touches of Cobalt Blue to the blue flowers, touches of Light Peony + Cobalt Blue (1:1) to the purple flowers, and dots of Raw Sienna to the yellow flowers.

Willow and Waterfall

I LOVE THE SOUND OF A BABBLING BROOK ON A
SUMMER'S DAY. WATER CAN BE CHALLENGING TO
PAINT. REMEMBER, WATER ITSELF DOESN'T HAVE
A COLOR; IT REFLECTS THE COLORS OF THE SKY
AND ITS SURROUNDINGS.

MATERIALS LIST

SURFACE
12" × 16" (30cm × 41cm) Canson Montval cold press watercolor paper

BRUSHES
1-inch (25mm) wash; nos. 3, 5, 6 and 10 round; nos. 4 and 8 filberts;
no. 8 flat; no. 2 fan

PLAID FOLKART ACRYLIC PAINT
Apple Orchard, Coastal Blue, Forest Moss, Soft Apple, Sunny Yellow

PLAID FOLKART ARTIST'S PIGMENTS
Brilliant Ultramarine, Butler Magenta, Hauser Green Dark, Payne's Gray,
Raw Umber, Red Light, Sap Green, Titanium White

OTHER SUPPLIES
drafting tape (not masking tape), facial tissue, graphite transfer paper,
masking fluid, sharp pencil or stylus, small sea sponge

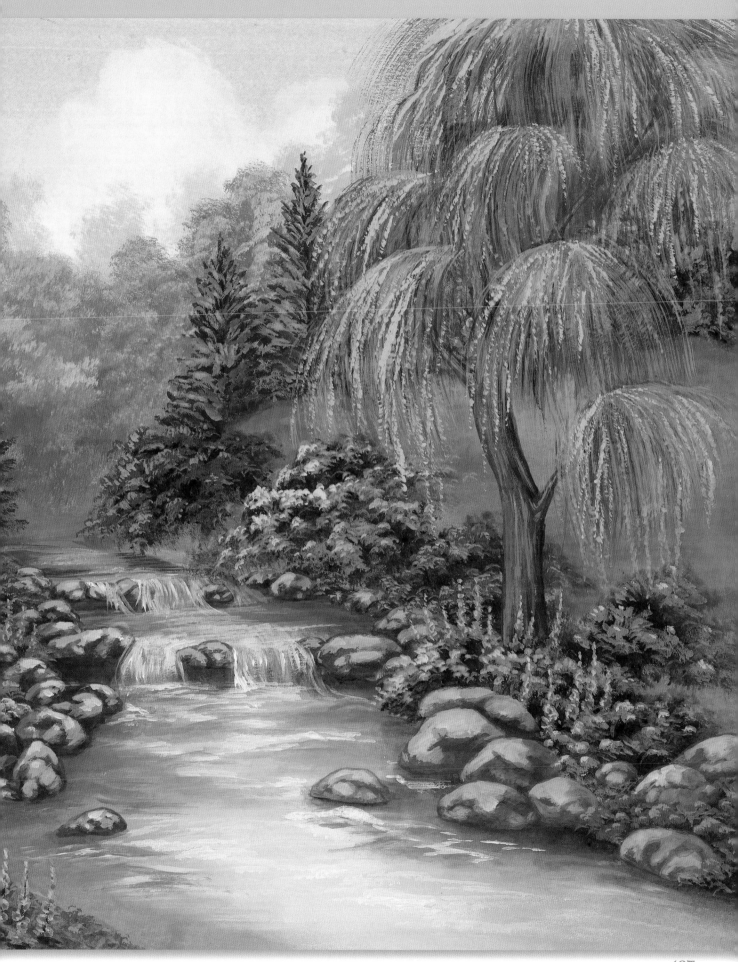

PATTERN

This pattern may be hand traced or photocopied for personal use only. Enlarge at 200% on a photocopier to bring it up to full size.

PREPARE FOR PAINTING

Use the drafting tape to mask the edges of an 11" × 14" (28cm × 36cm) area on your paper. Transfer the design with graphite transfer paper and a sharp pencil or stylus. With the masking fluid, protect the tree trunks and rocks (see page 11). Cover the water if you wish.

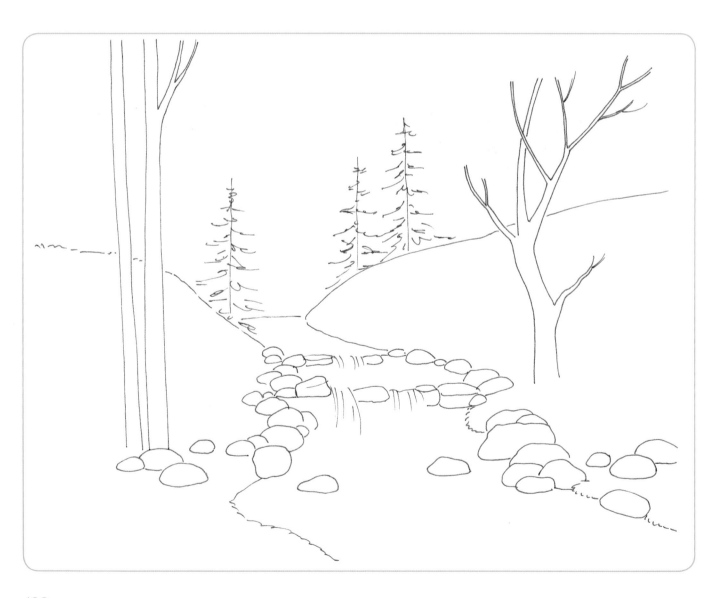

Color Mixes

Red Light + Sunny Yellow (1:1)

Sunny Yellow + Raw Sienna (1:1)

Apple Orchard + Sunny Yellow (2:1)

Apple Orchard + Titanium White (1:1)

Sap Green + Apple Orchard (1:1)

Hauser Green Dark + Soft Apple (1:1)

Payne's Gray + Sap Green (2:1)

Sap Green + Coastal Blue (1:1)

Butler Magenta + Coastal Blue + Titanium White (1:1:1)

Butler Magenta + Coastal Blue (1:1)

Raw Sienna + Raw Umber + Titanium White (1:1:1)

Payne's Gray + Raw Umber (2:1)

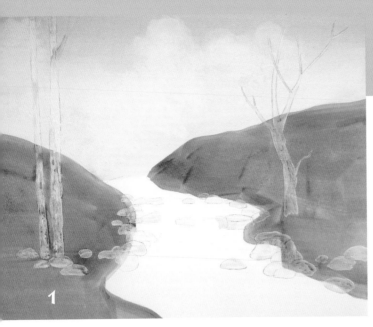

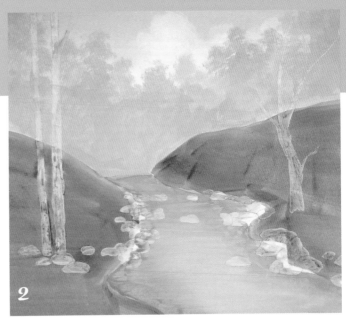

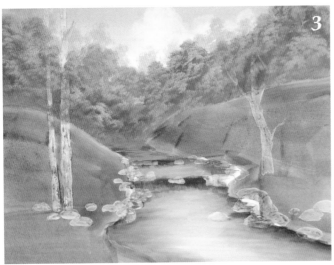

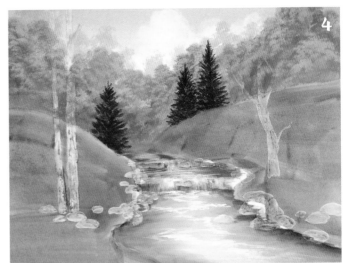

Step 1: Block in Sky, Grass

Wet the sky with clean water and paint a wash of Coastal Blue with the 1-inch (25mm) wash. Blot out some clouds with crumpled facial tissue (See page 14). Touch up the clouds with a little Titanium White and the no. 5 round if necessary. Paint the grass with a wash of Sap Green.

Step 2: Add Water, Background Foliage

With the no. 10 round, paint the water with Sap Green + Coastal Blue (1:1). While it is still wet, paint Titanium White in the center of the water and blend with horizontal strokes. (See page 23 for more instruction on painting rushing water.) Stipple background foliage with Butler Magenta + Coastal Blue + Titanium White (1:1:1) and the no. 8 filbert (see page 13).

Step 3: Add Foliage, Darken Water

Stipple more foliage with Sap Green + Coastal Blue (1:touch). Blend this color into the distant water. Add highlights to the foliage with Soft Apple. With the no. 8 flat, add dark colors to the water with Payne's Gray + Sap Green (2:1). Glaze a little Forest Moss along the edges.

Step 4: Add Falls, Pine Trees

With the chisel edge of the no. 8 flat, pat Titanium White ripples on the water. Paint curved, vertical strokes where the water falls over the rocks.

Tap in the evergreens with Hauser Green Dark and the edge of the no. 8 filbert.

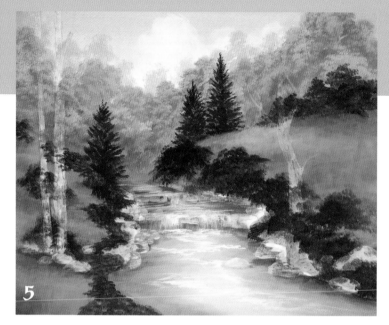

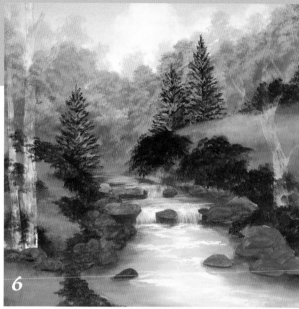

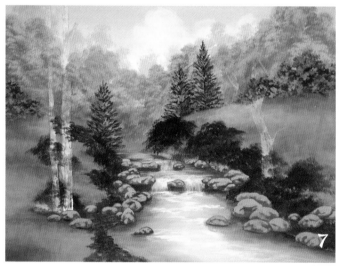

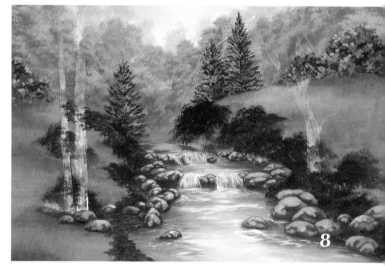

Step 5: Add Shrubbery, Detail Grass

With the no. 8 filbert, stipple shrubbery with Sap Green. Paint grass with short, vertical strokes of the no. 8 flat and Apple Orchard, Apple Orchard + Titanium White (1:1), Forest Moss and Sap Green + Apple Orchard (1:1).

Step 6: Detail Evergreens, Basecoat Rocks

Highlight the evergreens with Hauser Green Dark + Soft Apple (1:1) and plain Soft Apple. Add trunks with Raw Umber and the no. 3 round.

Paint the rocks with the no. 6 round and Raw Umber + Payne's Gray + Titanium White (1:touch:touch). Glaze Payne's Gray underneath them.

Step 7: Highlight Rocks, Add Blooms to Shrubs

Highlight the rocks with Titanium White + Raw Umber (1:generous touch) and the no. 6 round.

With the no. 4 filbert, paint Butler Magenta + Coastal Blue (1:1) on the background bushes. Add more flowers with Butler Magenta.

Step 8: Detail Rocks, Highlight Blooms

Add more darks to the rocks with Payne's Gray and Raw Umber. Add warmer highlights with various brush mixes of Raw Sienna and Titanium White. (See page 22 for additional instruction on painting rocks.)

Add highlights to the purple bushes with Butler Magenta + Titanium White (1:1). Add more water ripples around the rocks as you did in Step 4.

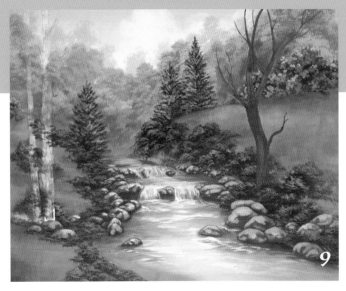

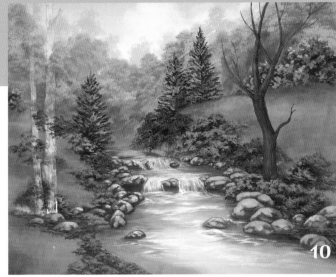

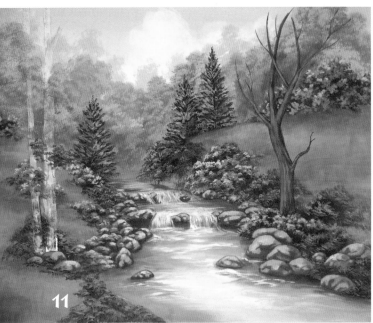

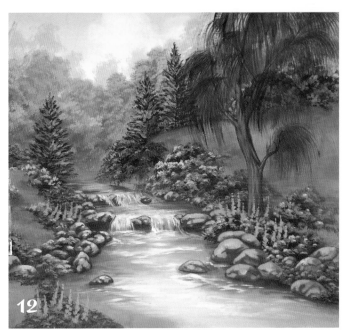

Step 9: Detail Foliage, Paint Willow Trunk

With the no. 8 filbert, highlight the foliage along the river with Apple Orchard. Bring more foliage up to overlap the edges of the rocks. Glaze a little Hauser Green Dark behind the willow.

Uncover the willow and paint the trunk with Raw Umber + Titanium White (1:touch) with the no. 6 round.

Step 10: Detail Trunk, Add Flowers to Banks

Shade the willow trunk with Payne's Gray + Raw Umber (2:1), using the no. 6 round (see page 20 for additional instruction on painting tree bark). Stipple flowers on the river bank with the no. 4 filbert and Red Light + Sunny Yellow (1:1), Sunny Yellow + Raw Sienna (1:1) and Butler Magenta + Coastal Blue (1:1).

Step 11: Add Highlights

Brush mix Titanium White into the flower mixes from Step 10 and dot highlights onto the flowers. Highlight the willow trunk with Raw Sienna + Raw Umber + Titanium White (1:1:1) and the no. 6 round.

Step 12: Add Leaves, More Flowers

Dilute Sap Green with water to a creamy consistency and paint foliage on the willow with the no. 2 fan brush. Mix Brilliant Ultramarine + Titanium White (1:1) and add blue flower spikes to the banks with the no. 3 round. Add more red flowers along the foreground following the instructions in Steps 10 and 11.

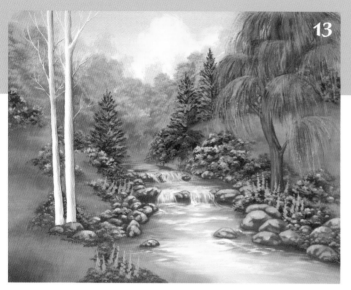

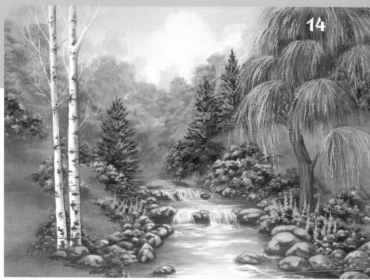

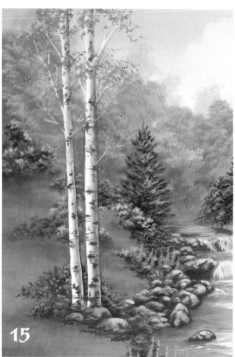

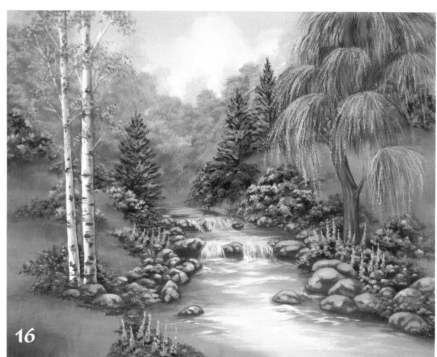

Step 13: Paint Aspens, Detail Willow Foliage

Remove the mask from the aspen trees. With the no. 3 round, touch them up with Titanium White and add little branches. Shade their right sides with thin Raw Umber.

Add lighter foliage to the willow with the no. 2 fan brush and Apple Orchard + Sunny Yellow (2:1).

Step 14: Detail Trees

With the edge of the no. 2 fan, stipple highlights on the willow with Apple Orchard + Titanium White (1:1). With the no. 3 round, paint the bark texture on the aspen trees with Raw Umber + Payne's Gray (1:touch).

Step 15: Add Aspen Leaves, More Flowers

Glaze the aspen trunks with a little Raw Sienna and the no. 3 round. Use a sea sponge to pat on Apple Orchard foliage on the aspens. Add darks to the blue flowers with Brilliant Ultramarine + Titanium White (1:touch).

Step 16: Add Final Details

Sponge more foliage on the aspens with Sunny Yellow + Raw Sienna (1:1). Dot on a few pure Sunny Yellow leaves with the no. 3 round. Highlight the blue flowers with Titanium White + Brilliant Ultramarine (1:touch) and add a few stems with Sap Green.

Autumn Barn

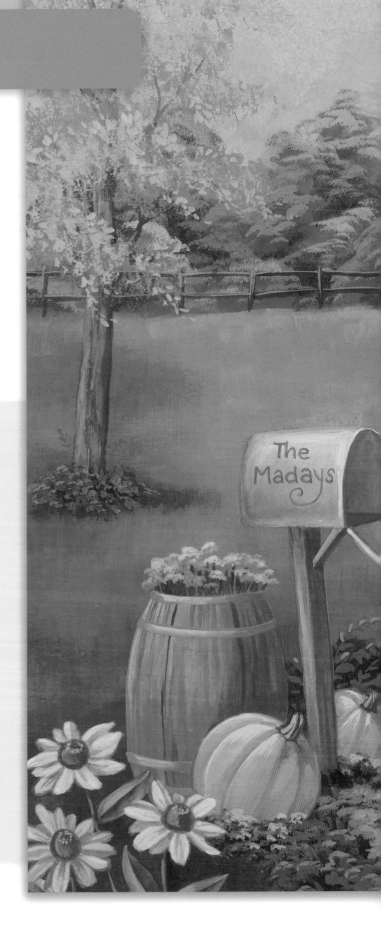

THIS PAINTING BRINGS BACK FOND MEMORIES OF A TRIP TO VERMONT IN AUTUMN. YOU CAN PERSON- ALIZE THIS PAINTING BY PUTTING YOUR NAME ON THE MAILBOX. IT WOULD ALSO MAKE A NICE GIFT IF YOU PUT THE RECIPIENT'S NAME THERE.

MATERIALS LIST

SURFACE
12" × 16" (30cm × 41cm) Canson Montval cold press watercolor paper

BRUSHES
1-inch (25mm) wash; nos. 3 and 6 rounds; nos. 4 and 8 filberts

PLAID FOLKART ACRYLIC PAINT
Apple Orchard, Coastal Blue, Soft Apple, Sunflower, Tangerine, Violet Pansy

PLAID FOLKART ARTIST'S PIGMENTS
Light Red Oxide, Payne's Gray, Raw Sienna, Raw Umber, Sap Green, Titanium White, Yellow Light, Yellow Ochre

OTHER SUPPLIES
drafting tape (not masking tape), graphite transfer paper, masking fluid, sea sponge, sharp pencil or stylus, white transfer paper

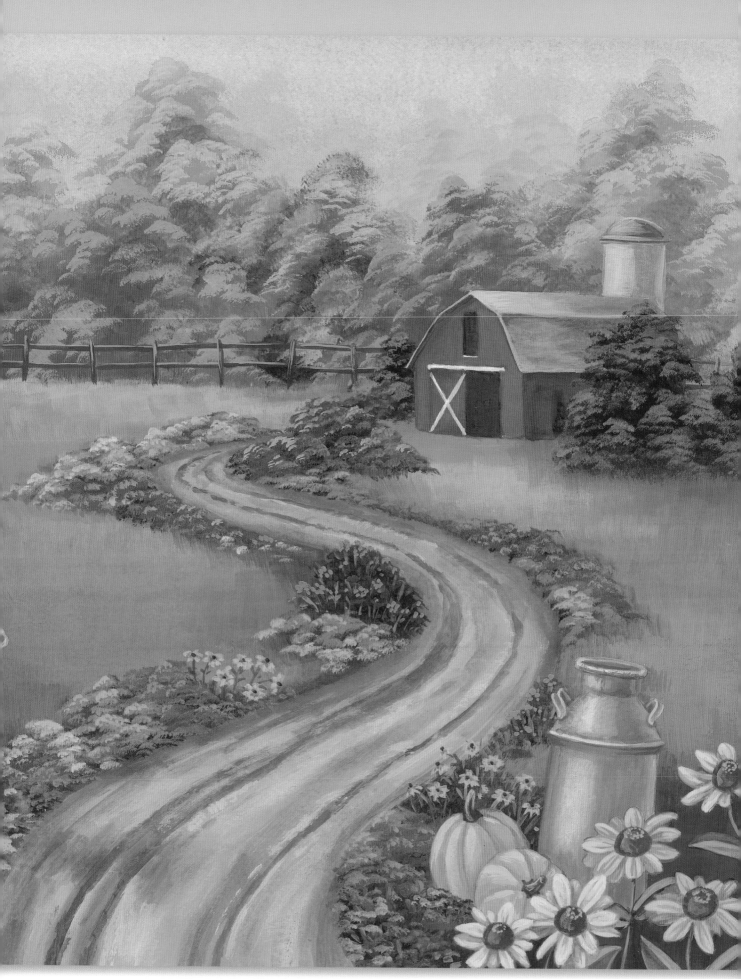

PATTERN

This pattern may be hand traced or photocopied for personal use only. Enlarge at 200% on a photocopier to bring it up to full size.

PREPARE FOR PAINTING

Use the drafting tape to mask the edges of an 11" × 14" (28cm × 36cm) area on your paper. Transfer the pattern, except for the fence and distant trees, with the graphite transfer paper and a sharp pencil or stylus (see page 10). With the masking fluid, protect the design (see page 11).

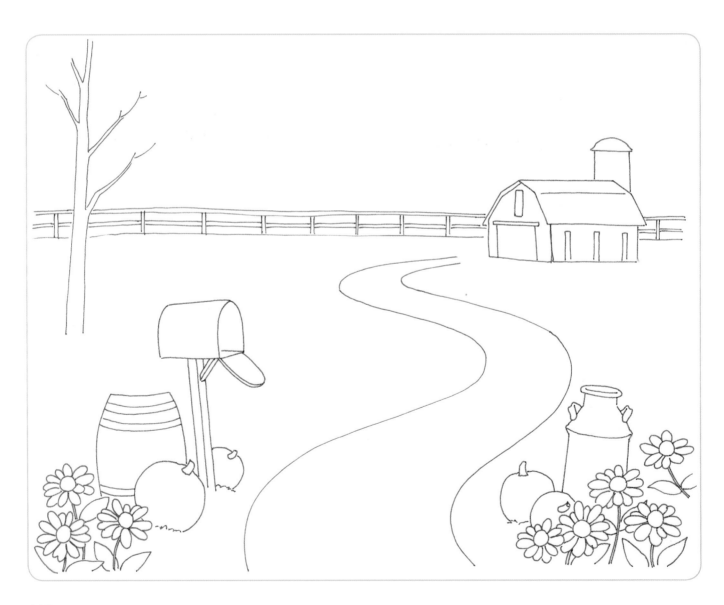

COLOR MIXES

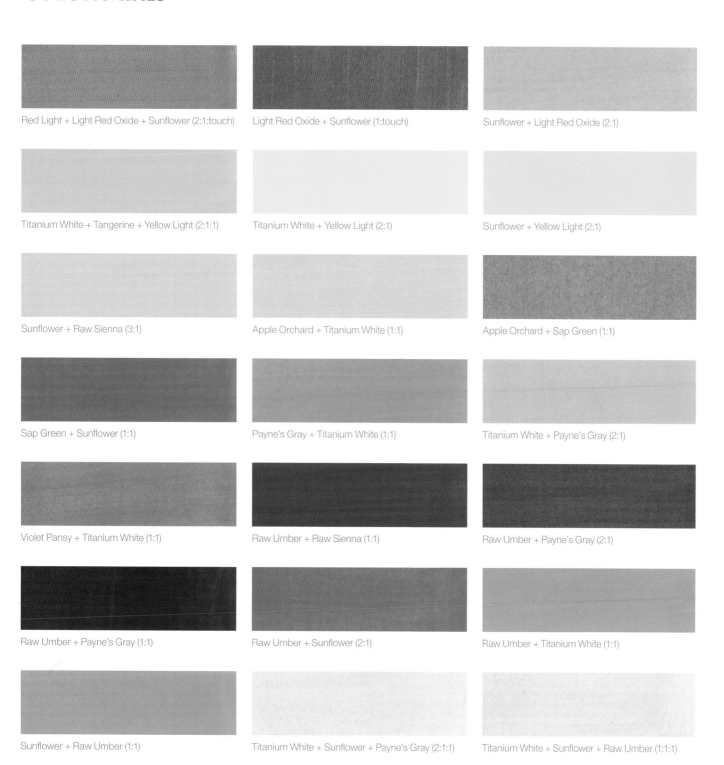

Red Light + Light Red Oxide + Sunflower (2:1:touch)

Light Red Oxide + Sunflower (1:touch)

Sunflower + Light Red Oxide (2:1)

Titanium White + Tangerine + Yellow Light (2:1:1)

Titanium White + Yellow Light (2:1)

Sunflower + Yellow Light (2:1)

Sunflower + Raw Sienna (3:1)

Apple Orchard + Titanium White (1:1)

Apple Orchard + Sap Green (1:1)

Sap Green + Sunflower (1:1)

Payne's Gray + Titanium White (1:1)

Titanium White + Payne's Gray (2:1)

Violet Pansy + Titanium White (1:1)

Raw Umber + Raw Sienna (1:1)

Raw Umber + Payne's Gray (2:1)

Raw Umber + Payne's Gray (1:1)

Raw Umber + Sunflower (2:1)

Raw Umber + Titanium White (1:1)

Sunflower + Raw Umber (1:1)

Titanium White + Sunflower + Payne's Gray (2:1:1)

Titanium White + Sunflower + Raw Umber (1:1:1)

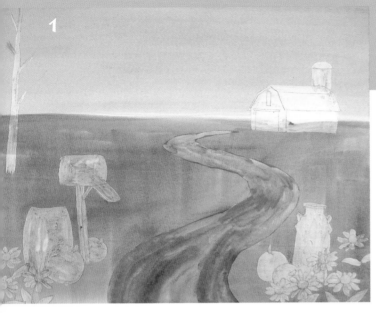

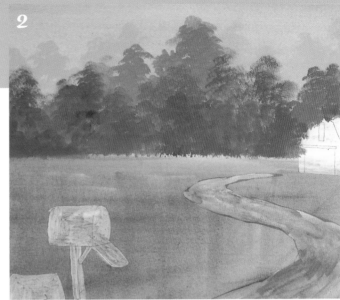

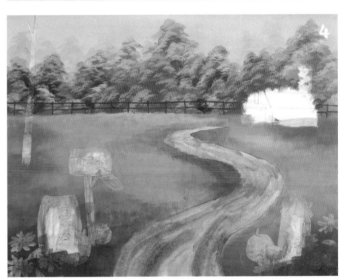

Step 1: Paint Sky, Ground, Path

Wet the sky with clean water. Paint a wash of Coastal Blue with the 1-inch (25mm) wash brush. Let the sky dry thoroughly, then paint the ground with a wash of Sap Green. Uncover the path and paint it with Raw Umber, using the no. 6 round.

Step 2: Stipple in Background Trees

Stipple the background trees with the no. 8 filbert (see page 13). The most distant treetops are Soft Apple. The yellow trees are Yellow Ochre. The red trees are Light Red Oxide + Sunflower (1:touch). The green trees are Sap Green + Sunflower (1:1).

Step 3: Shade Background Trees

Add darks to the trees. Use Raw Sienna for the yellow trees, Sap Green for the green trees and Raw Umber and Light Red Oxide for the red trees.

Brush mix various combinations of Apple Orchard, Yellow Ochre, Sap Green and Sunflower, and paint the grass with short strokes of the 1-inch (25mm) wash brush.

Step 4: Highlight Trees, Add Fence

Stipple highlights onto the trees with the no. 8 filbert. Use Sunflower + Yellow Light (2:1) for the yellow trees, Sunflower + Light Red Oxide (2:1) for the red trees and Soft Apple for the green trees.

Transfer the fence with the white transfer paper and paint it with Raw Umber and the no. 3 round.

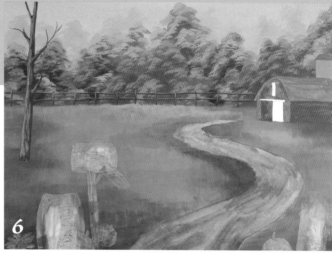

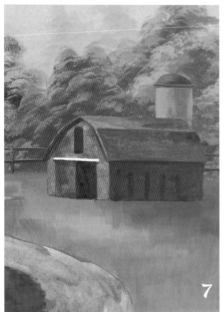

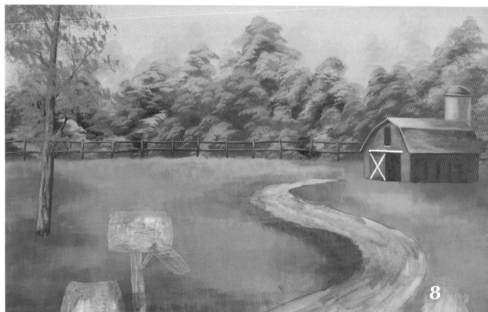

Step 5: Highlight Fence, Paint Tree Trunk

Highlight the fence with Raw Umber + Titanium White (1:1). Uncover the tree and paint the trunk with Raw Umber, using the no. 6 round. Shade with glazes of Raw Umber + Payne's Gray and the no. 3 round. Uncover the barn and retransfer the details as necessary.

Step 6: Highlight Tree, Paint Barn

Highlight the tree with Raw Umber + Titanium White (1:1) and the no. 3 round. Paint the barn with Light Red Oxide + Sunflower (1: touch) and the no. 6 round. The silo is Sunflower + Raw Umber (1:1). Paint the roofs with Payne's Gray + Titanium White (1:1).

Step 7: Detail Barn

Shade the barn with Light Red Oxide + Raw Umber (1:1). The inside of the door and windows are Raw Umber. Shade the roofs with Raw Umber + Payne's Gray (2:1), and the silo with Raw Umber + Sunflower (2:1).

Step 8: Highlight Roofs, Add Leaves

With the no. 3 round, highlight the roofs with Titanium White + Sunflower + Payne's Gray (2:1:1), and the silo with Titanium White + Sunflower + Raw Umber (1:1:1). Add details with Titanium White.

Add leaves to the tree with Apple Orchard and the sea sponge (see page 15). Let dry, then stamp Yellow Ochre foliage on the tree with the sponge.

TIP

When you mix Titanium White with another color, the results can be cool and gray. Adding a little Sunflower to the mixes on the barn will warm the colors.

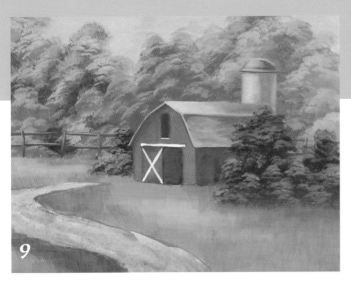

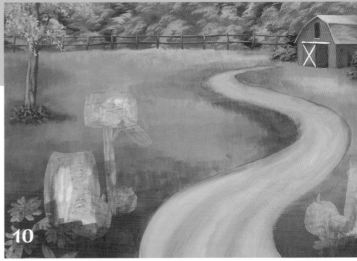

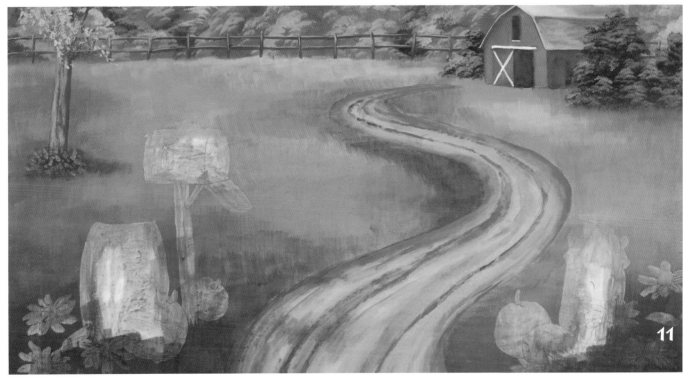

Step 9: Place Bushes Around Barn

Stipple bushes next to the barn with Sap Green and the no. 8 filbert. Leave gaps where the barn shows through. Stipple lighter foliage with Apple Orchard.

Sponge more leaves on the large tree with Sunflower + Yellow Light (2:1). Add a few individual leaves with the same mix and the no. 3 round.

Step 10: Repaint Path

Paint the path with Sunflower + Raw Sienna (3:1), using the no. 6 round. Shade the edges with Raw Sienna.

Stipple Sap Green under the tree with the no. 8 filbert. Add foliage under the tree with Apple Orchard and the no. 3 round.

Step 11: Detail Path

With the no. 6 round, paint the ridges and shadows on the path with Raw Umber + Raw Sienna (1:1), blending with clean water as you go. Glaze a very thin wash of Raw Sienna across the front of the barn.

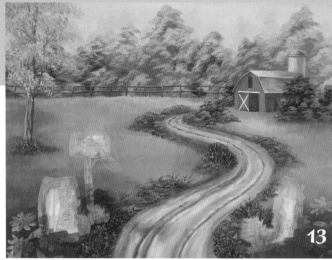

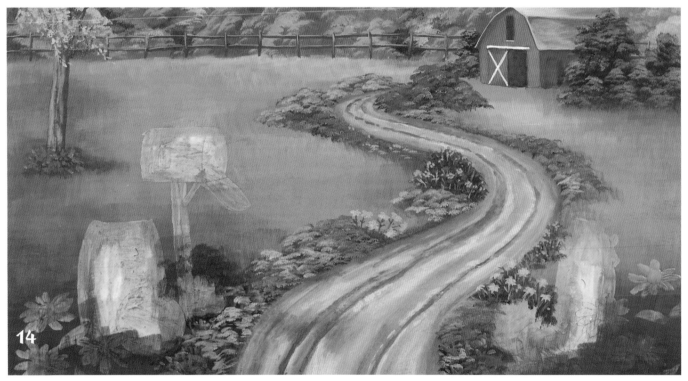

Step 12: Highlight Path

Brush mix a little Titanium White into the Sunflower/Raw Sienna mixture and highlight the ridges on the path with the no. 3 round. Stipple Sap Green alongside the path with the no. 8 filbert.

Step 13: Develop Foliage

Develop the foliage along the path with Apple Orchard and Apple Orchard + Sap Green (1:1).

Stipple the foliage in the background with the no. 8 filbert, and switch to the no. 3 round in the foreground and paint more individual leaves and stems.

Step 14: Add Flowers

Stipple flowers as shown with the no. 8 filbert. Use Violet Pansy + Titanium White (1:touch), Tangerine, Red Light + Sunflower (1: touch) and Yellow Light + Sunflower (1:touch). Add more flowers with the no. 3 round. The lighter purple flowers are Violet Pansy + Titanium White (1:1).

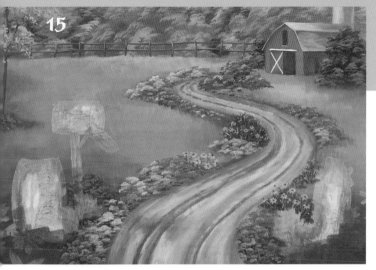

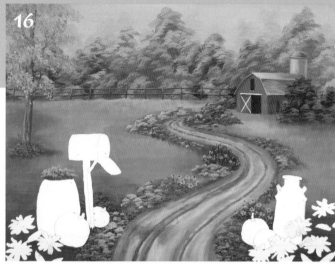

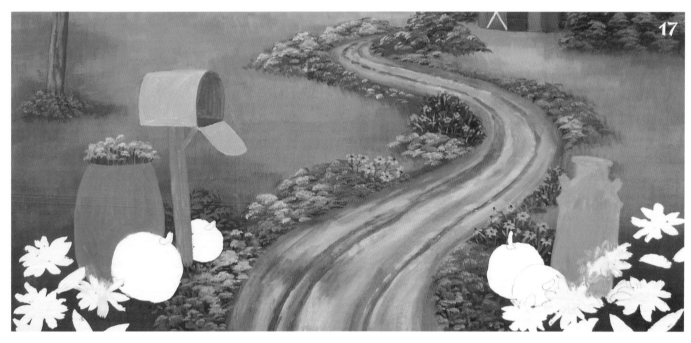

Step 15: Highlight Flowers

Brush mix Titanium White into each of the flower mixes, and stipple highlights with the no. 4 filbert. With Light Red Oxide + Sunflower (1:touch) and the no. 3 round, paint leaves around the tree and mailbox, and add to the yellow flowers. Dot Raw Umber into the centers of the yellow flowers.

Step 16: Add Foreground Flowers

Paint stems in the barrel with Sap Green and the no. 3 round. Stipple yellow and orange flowers with the no. 4 filbert.

Remove the remaining masking fluid. Retransfer the details and remask the foreground flowers that overlap the barrel and milk can.

Step 17: Paint Foreground Elements

Highlight the flowers in the barrel as before. Paint the barrel and mailbox post with Raw Umber + Sunflower (2:1) and the no. 3 round. Paint the milk can and mailbox with Titanium White + Payne's Gray (2:1). Brush mix more Payne's Gray into the mix for the inside of the mailbox.

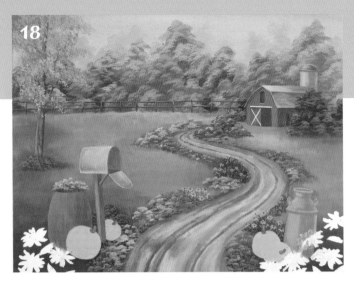

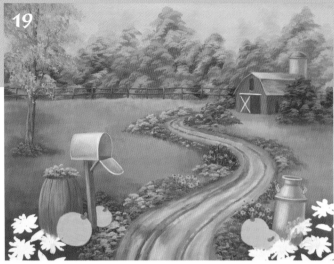

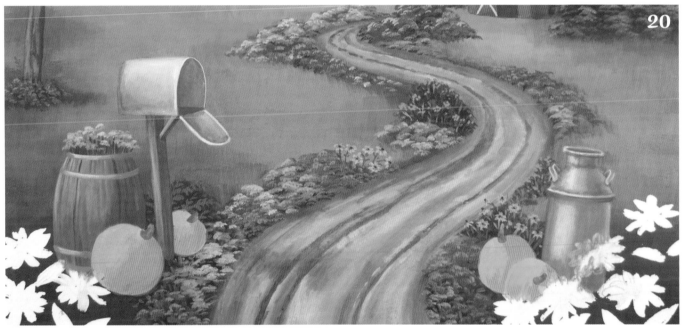

Step 18: Detail Foreground Elements

Shade the barrel and post with Raw Umber + Raw Sienna (1:1) and the no. 3 round. Blend with clean water. Shade the milk can and mailbox with Payne's Gray + Titanium White (1:1). Paint the pumpkins with Tangerine. The stems are Sap Green + Sunflower (1:1).

Step 19: Highlight Foreground Elements

Highlight the mailbox and milk can with Titanium White + Payne's Gray (1:touch) and the no. 3 round. Add Payne's Gray details. Highlight the barrel and post with Titanium White + Sunflower + Raw Umber (1:1:1). Detail with Raw Umber.

Step 20: Detail Metal Objects, Barrel

Glaze a little rust on the mailbox and milk can with the no. 3 round and Light Red Oxide + Raw Sienna (1:touch). Paint the bands on the barrel with Payne's Gray + Titanium White (1:1). Highlight with Titanium White + Payne's Gray (1:touch). Shade the pumpkins with Tangerine + Light Red Oxide (1:touch).

Step 21: Detail Pumpkins

Detail the pumpkins with Light Red Oxide + Tangerine (1:touch). Highlight with Titanium White + Tangerine (1:touch). Detail the stems with Sap Green + Raw Umber (1:touch). Highlight with Sunflower + Sap Green (1:touch).

Step 22: Base Zinnias

Paint flowers and foliage as before, overlapping the pumpkins. Remove the remaining mask. With the no. 3 round, paint the zinnias with Yellow Light + Tangerine (1:slight touch) and some with Tangerine. The centers are Raw Umber. The leaves and stems are Apple Orchard + Sap Green (1:1).

Step 23: Shade Zinnias

With the no. 3 round, shade the leaves with diluted Sap Green. Shade and detail the yellow flowers with Yellow Ochre and Raw Sienna, and the orange flowers with Red Light + Light Red Oxide + Sunflower (2:1:touch).

Step 24: Highlight Zinnia Centers, Yellow Petals

With the no. 3 round, highlight the flower centers with Raw Umber + Sunflower (2:1). Dot some pollen with Yellow Light + Tangerine (1:touch). Highlight the yellow flower petals with Titanium White + Yellow Light (2:1). Glaze a little Yellow Light over the top.

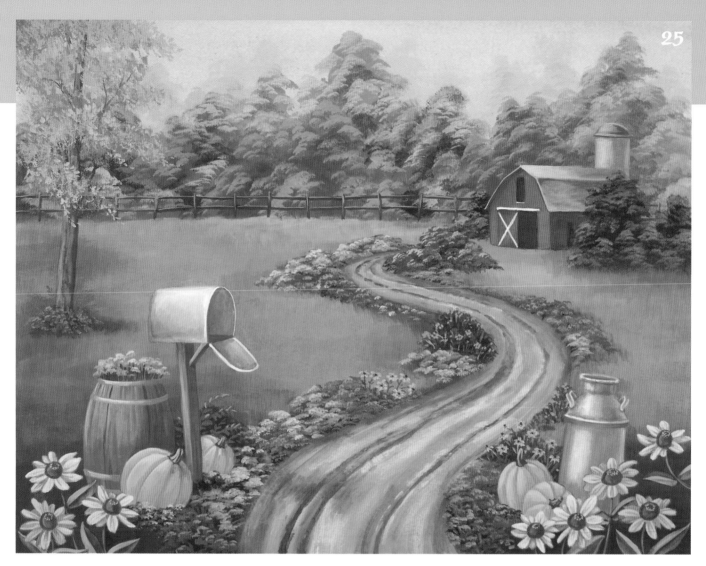

Step 25: Add Final Highlights

Highlight the orange flower petals with Titanium White + Tangerine + Yellow Light (2:1:1). Highlight the leaves with Apple Orchard + Titanium White (1:1). Glaze very thin Yellow Light over both. Write your name on the mailbox with diluted Payne's Gray if desired.

TIP

Pouring your dirty paint-rinse water down the drain can be hard on your pipes. Try pouring it into an old bucket and letting the water evaporate. A scum of the old paint will remain in the bucket. I find that the bucket never gets full because the water evaporates quickly enough before I pour more in.

Resources

Paints, Brushes & Paper

Plaid Enterprises, Inc.

3225 Westech Dr.
Norcross, GA 30092
Phone: 800-842-4197

www.plaidonline.com

Royal & Langnickel

6707 Broadway
Merrillville, IN 46410
Phone: 800-247-2211

www.royalbrush.com

Canson, Inc.

21 Industrial Dr.
South Hadley, MA 01075

www.canson-us.com

Canadian Retailers

Folk Art Enterprises

P.O. Box 1088
Ridgetown, ON N0P 2C0
Phone: 800-265-9434

MacPherson Arts & Crafts

91 Queen St. E.
P.O. Box 1810
St. Mary's, ON N4X 1C2
Phone: 800-238-6663

www.macphersoncrafts.com

Index

The best in art instruction is from North Light Books!